Translated from the Italian by D.H.Lawrence

SHORT SICILIAN NOVELS

(Novelle Rusticane)

Giovanni Verga

with an introduction and chronology
by Eric Lane

Dedalus / Hippocrene

Fiction
Verga

Published in the UK by Dedalus Ltd,
Langford Lodge, St Judith's Lane, Sawtry, Cambs, PE17 5XE

ISBN 1 873982 40 2

Published in the USA by Hippocrene Books Inc, 171, Madison Avenue, New York, NY10016.
Distributed in Canada by Marginal Distribution,
Unit 103, 277 George Street North, Peterborough, Ontario, KJ9 3G9
Distributed in Australia by Peribo Pty Ltd, 26 Tepko Road, Terrey Hills, N.S.W.2084
Distributed in South Africa by William Waterman Publications Ltd, P.O.Box 5091, Rivonia 2128

Publishing History
First published in Italy in 1883 as Novelle Rusticane
First published in England in 1928
First Dedalus edition in 1984
Second Dedalus edition 1994

Introduction copyright © Eric Lane 1984
Translation copyright © The Estate of Frieda Lawrence Ravagli 1984

Printed in India by Thomson Press (India) Limited

A C.I.P. listing for this title is available on request.

P TB

DEDALUS EUROPEAN CLASSICS

Dedalus European Classics began in 1984 with D.H. Lawrence's translation of Verga's *Mastro Don Gesualdo*. One of the editors' first aims was to make all of Verga's major work available in English and a new translation of *I Malavoglia* was commissioned from Judith Landry, which was published in the Autumn of 1985. The publication of D.H.Lawrence's translations of Verga's short stories *Short Sicilian Novels* (1984) and *Cavalleria Rusticana* (1987) completed this undertaking.

In addition to rescuing major works of literature from being out of print, the editors' other main aim was to redefine what constituted a "classic" and works that few other publishers would include as such appeared in our list - Sue's *Mystery of Paris*, Leroux's *The Phantom of the Opera*, Meyrink's *Golem*.

The development of various different stands in our list was recognised in 1990 by dividing our European Classic list into three: Decadence from Dedalus, A Dedalus Nobel Prize Winner, and Dedalus European Classics. At the same time our familiar burgundy covers gave way to a multitude of different styles as we sought to make our books as interesting outside as they are inside.

Verga's reputation and the standing of Italian Literature in general has risen in the last ten years in the English speaking world, so not only have we been able to reprint *The Short Sicilian Novels* and *I Malavoglia (The House by the Medlar Tree)* but we have been able to add a fifth book by Verga to our list. Christine Donougher's first ever English translation of the 1871 novel *La Storia di una Capinera (Sparrow)* allows us to enjoy one of Verga's early works, written before he had embraced social realism.

Books by Giovanni Verga available from Dedalus:

Mastro Don Gesualdo
(translated under the same title by D.H.Lawrence)

Cavalleria Rusticana
(translated under the same title by D.H.Lawrence)

I Malavoglia
(translated by Judith Landry as The House by the Medlar Tree)

La Storia di una Capinera
(translated by Christine Donougher as Sparrow)

Novelle Rusticane
(translated by D.H.Lawrence as Short Sicilian Novels)

CHRONOLOGY

1840 2 September. Giovanni Verga was born in Catania, Sicily. His family were landowners and members of the minor nobility.

1848/9 Year of Revolutions in Italy.

1857 Wrote his first novel, "Amore e Patria" (unpublished).

1858 Enroles as a student of law at Catania University.

1859 Beginning of the Italian War of Independence.

1860 Insurrections in Sicily in April are followed by the arrival of Garibaldi and his volunteers who take Sicily from the Bourbons.
 Verga joins the National Guard founded after the arrival of Garibaldi. He is one of the founders and the editor, of the weekly political magazine, Roma degli Italiani.

1861 The Bourbons are forced out of Naples, and Garibaldi surrenders Naples and Sicily to Victor Emanuel, the Piedmontese king. In plebiscites the people of Southern Italy vote to be part of the newly formed Italian Kingdom under Victor Emanuel.
 Verga abandons his legal studies and publishes his first novel, "I Carbonari della Montagna," at his own expense.

1863 His patriotic novel, "Sulle lagune", is published in a magazine.
 His father dies.

1864	Florence becomes the new capital of Italy, replacing Turin.
1865	Verga's first visit to Florence. He becomes a frequent visitor and takes up permanent residence in 1869.
1866	The Austrians retreat from Venice which becomes part of Italy. His novel, "Una Peccatrice" is published.
1869	Settles in Florence, where he meets Luigi Capuana, the realist writer and theorist. Begins an affair with the 18 year old, Giselda Foljanesi.
1870	Rome is taken, and becomes the Italian capital in 1871.
1871	Zola's "La Fortune de Rougon", the first book in the Rougon-Macquart cycle, is published. Zola's theories and Naturalism become increasingly important and controversial in Italy. Verga publishes "Storia di una capinera", which is an immediate success.
1872	Goes to live in Milan, where he spends most of the next 20 years. Frequents the literary salons of the city, making a name for himself in the capital of Italian publishing. Giselda Foljanesi marries the Catanese poet Mario Rapisardi.
1873	"Eva" is published, and is criticized for its immorality.
1874/6	"Tigre Reale", "Eros", and the novella "Nedda" are published.

1877	"L'Assommoir" of Zola is published and has an overwhelming influence in Italy. Verga publishes his collected short stories, "Primavera e altri racconti."
1878	His mother dies, to whom he was greatly attached.
1880	"Vita dei Campi" is published. Visits Giselda Foljanesi.
1881	"I Malavoglia" is published. Verga is disappointed by its lack of success. Begins an affair with countess Dina Castellazi, who is married and in her twenties. It lasts most of his life.
1883	Goes to Paris, and visits Zola at Meridan. Also goes to London. Publishes "Novelle Rusticane" and the novel "Il Marito di Elena", and "Per le Vie". Visits Catania where he sees Giselda Foljanesi. In December Rapisardi discovers a compromising letter from Verga to his wife, and so Giselda is forced to leave and settle in Florence.
1884	The play of "Cavalleria Rusticana" is put on with great success in Turin, with Eleonora Dusa playing Santuzza. The end of Verga's affair with Giselda Foljanesi.
1886 - 7	Passes most of his time at Rome. The publication of a French translation of "I Malavoglia" is without success.
1888	Returns to live in Sicily.

1889	"Mastro-don Gesualdo" is published and is an immediate success. D'Annunzio publishes his novel, "Il Piacere".
1890	Mascagni's one act opera of "Cavalleria Rusticana" is put on and enjoys an overwhelming success. Verga sues Mascagni and Sonzogno for his share of the royalties.
1891	Publishes a volume of stories, "I Ricordi del capitano d'Arce". Wins his case in the Court of Appeal, getting 143,000 lire, (which was a large sum then and put an end to the financial problems which had beset him).
1895	Goes with Capuana to visit Zola in Rome.
1896	The defeat at Adua puts an end to Italy's colonial expansion. Verga criticizes the demonstrations against the war. Begins writing the third novel in his "I Vinti" cycle, "La Duchessa di Leyra", but never completes it.
1898	There are riots in Milan, after the price of bread is increased, which are violently put down by the army. Verga applauds their actions as a defence of society and its institutions.
1900 - 3	Various of his plays are put on, but Verga's energies turn away from his writing to managing his business interests and living quietly in Sicily.
1915	Declares himself in favour of Italian involvement in WW1, and anti-pacificism.

1920 His eightieth birthday is celebrated in Rome and Catania. In November he becomes a senator.

1922 27 January Verga dies in Catania.
Mussolini comes to power.

CONTENTS

INTRODUCTION

Giovanni Verga, despite being Italy's greatest novelist and having been translated by D. H. Lawrence, is almost totally unknown in England. This is a situation which at some time must change, with Verga getting the critical acclaim he deserves, and a readership as large as Thomas Hardy or Zola. When is another matter, as there is little interest in Italian Literature in this country, with very few writers known all all. The days when Italian Literature was accorded the stature of Latin and Greek, as the third classical language are long since gone. Elizabeth I, the most accomplished of English monarchs spoke and wrote Italian fluently, poets such as Milton wrote poems in Italian.

It was Italian that emerged as Europe's first great national culture, when Latin was replaced by the vernacular in Europe. The Florentine writers, Dante, Petrarch and Boccaccio prepared the way for the flowering of the Renaissance, and Ariosto, Macchiavelli, Castiglione and Tasso. The excellence of the Renaissance gave way to the second rate, as the Italian City States declined, as the peninsular became a battle ground for the French and Spanish. It was the victory of Spain, and their championing of the Counter Reformation, which made ideas dangerous and literature empty.

Italian Literature has yet to recover from the effects of this body blow to its culture. The few writers of excellence it has produced since the Renaissance gaining scant attention

outside the confines of the Italian peninsula. Leopardi, Manzoni, Pirandello are known, if not read, while Verga, whose novel "I Malavoglia", was translated into English in the 1890s, remains a stranger to the bookshelves of the British Isles.

The world Verga writes of, has perhaps more interest for us today than ever, as industrialization and modern technology has swept aside the poverty and neglect of centuries in Sicily. It is a world where the peasant and the fisherman had to fight an epic battle with the elements and the soil for survival — a struggle weighted against them by the feudal structure of their society.

* * *

ITALY IN 1840

Sicily was one of the poorest of the Italian states in 1840. It was ruled from Naples by the Bourbons, and had little in common with the advances of the Industrial Revolution as its feudal agrarian life continued much the same way it had for centuries. There was little wealth to be shared, so the upper classes exploited the lower without compassion. The Bourbons like the other ruling families in Italy were far from secure. The moderate reforms of the Enlightenment and the advent of Napoleon had created aspirations which the Restoration did little to satisfy. Constitutional government, economic and social reforms were striven for, but found little favour with the Italian monarchs. Insecure after their deposition by Napoleon they took refuge in absolutism and repression. Uprisings and rebellions culminated in a year of Revolution in the Italian States, which brought back Giuseppe Garibaldi from South America to lead the heroic defence of the newly created Roman Republic. The Revolutions of 1848/9 failed, but inspired the mood for change. The independent Kingdom of Piedmont in Northern Italy became the focus for the Italian Independence movement, which aimed for a united Italy under the Piedmont king Victor Emanuel. By 1859, with French help

the Piedmontese felt strong enough to wage war against the Austrians in Northern Italy. The early successes were brought to a halt, when the Emperor of France, Napoleon III, reached a treaty with Austria ending the war. Public opinion was outraged in Italy, and the government failed to return the conquered territories. There were ideas for extending the war to further parts of Italy, the most unlikely of these was to take the Bourbon Kingdom, of the Two Sicilies. Garibaldi's volunteer force of 1,000 set off in May of 1860, poorly equipped, to Sicily. By his own example and inspiration, popular support and amazingly poor resistance by the vastly superior Bourbon troops, Garibaldi conquered the island in just a few months. Later he crossed the Straits of Messina and completed the rout of the Bourbons, before the command of the war was taken from him by Victor Emanuel. With the annexation of Venice in 1866, and Rome in 1870, Italy was united under the rule of Piedmont. The capital of Italy changed from Turin to Florence in 1864, and to Rome in 1871, but despite its approach South the new state was very distant and inexplicable to the Sicilians; many of whom would have been happy to have had the Bourbons back.

Higher taxes, compulsory conscription and rule from Rome, with little change in their standard of living led to revolts in Sicily. Unification had meant the charismatic Garibaldi, referred to by some as the Second Christ, the reality was of rule from the uncomprehending Northern dynasty of Savoy.

* * *

There was not much of a prose tradition for Verga to follow. Foscolo had written the first Italian novel, the 'pathetic' "Ultime Lettere di Jacopo Ortis", an epistolary letter in the manner of Goethe's "Werther". A generation later Manzoni published "I Promessi Sposi", a novel which had, for the time, realism, psychological penetration and a wide list of characters, and for its heroes, two peasants. The novel was immediately successful, and was rewritten by Manzoni in a

new literary language based on modern Florentine, which became the model for later writers to follow. Most Italian critics consider this to be the finest novel of the century, but many readers find the overt moralizing and rose coloured view of his peasant heroes get in the way of the narrative gifts of Manzoni.

Verga spent his youth in the literary circles of Florence and Milan, and his early works are melodramatic popular novels about the decadence of the cities. The Bohemian poets were his main influence. His best work came when he renounced Romanticism for realism, and turned his attention from the empty pleasures of the city to the struggle for existence which was going on for the peasants and fishermen of his native Sicily. The short story "Nedda" was his first attempt at Verismo. By the end of the decade he had produced a volume of short stories in this manner, "Vita dei Campi". It was with the publication of "I Malavoglia" in 1881, Verga had turned realism into high art. In language distorted to echo the dialect of the fishermen, and metaphors limited to those of the sea, Verga tells the story of the Malavoglia family, with very little narrative and with the action coming through the characters' own words. What started out as a document of social realism ends as an epic tale of human endeavour, and the triumph of the spirit.

It was to be the first of a cycle, "I Vinti", (the Defeated) in which Verga would progress through society, examining how ambition and a desire for something more would cause the downfall of the 'vinti'. In "I Malavoglia" it is Ntoni who is the "vinto", as he aspires after the greater world of the city and its pleasures, bringing about the downfall of his family, as the harsh struggle for existence of the Sicilian fishermen left no room for any aspirations. In "Mastro-don Gesualdo" it is the self-made man Gesualdo's attempt to rise socially that brings him unhappiness. Apart from a few pages in the "Duchessa di Leyra" this was as far as Verga got in his cycle. Verga's reputation rests on the 2 novels of this cycle and his Short Stories. When it was first published "I Malavoglia" was a critical and a publishing failure, while "Mastro-don Gesualdo" was an immediate success, which

helped Verga overcome his financial problems. Verga was at his most productive during the 1880s, after which there was a decline in his output both in quantity and in quality. He turned some of his short stories into plays (and even into film scripts) one of which, "Cavalleria Rusticana" was a box office success. The operatta based on Verga's play has achieved a worldwide fame, and is much better known than the name or the work of its original creator.

"The Short Sicilian Novels", published in 1883, under the title of "Novelle Rusticane" are amongst the finest of Verga's stories, embodying the themes which are given fuller expression in his novels. There is no criticism of people's actions, however base, merely a statement that this is how life is. In the story of St. Joseph Ass, the ass gets progressively more ill-used as he changes owners and becomes more feeble by over exertion, but Verga makes no statement condemning his neglect, although his and the readers's sympathies are with the ass, instead he shows the need which drives the owners to get every ounce of sweat they can out of the ass. In Verga there are no villains or heroes, just actors doing what they must. There is respect for the hard suffering peasant, as he is put upon by society, but no programme for social change in Verga. The peasants who rise above their station do not find happiness, only more property, and lose what humanity they had. The decline of the gentry and landed classes is recounted dispassionatly as a historical process which is going on. The rich exploit as this is what being rich means.

Like Dickens, Verga wants a more human version of the world as it is, and is not for change. It is better to be what you were born to be, than rise upwards in society; Ntoni in the "Malavoglia", Gesualdo in "Mastro-don Gesualdo" and a whole assortment of characters in his stories become defeated by their desire for the unknown and a higher social position. Verga's view is that of the patrician, and perhaps this explains how like Orwell, his detachment and balance, proves more effective than the reformers' zeal. All of Sicily of the 19th century is presented to us and we can but choose to suffer the hardships and indignities with Verga's

characters and try and resist the chilling thought that this is how life is, as we aspire for something better even though it will lead only to defeat in Verga's world.

In Verga one can see the influence of Zola, without the excess, the storytelling gifts and rustic stoicism of Hardy, and the epic grandeur of Greek tragedy in the struggles of Verga's peasants. Where Manzoni idealized his peasant heroes into an idyll Verga ennobles them by turning the misery and squalour of their life into art.

<div style="text-align: right">

Eric Lane
February 1984

</div>

HIS REVERENCE

HE didn't have his monk's beard any more, nor his poor friar's hood, now that he got himself shaved every Sunday, and went out walking in his grand cassock of fine cloth, with his silk-lined cloak over his arm. And on those occasions when he was looking at his own fields, and his own vineyards, and his own flocks, and his own labourers, with his hands in his pocket and his little pipe in his mouth, if he ever did chance to recall the days when he washed up dishes for the Capucin monks and they out of charity put him a lay-brother's long frock on, he would make the sign of the cross with his left hand.

Yet if they hadn't taught him to say mass and to read and write, all out of charity, he would never have succeeded in wedging himself in among the first families of the place, nor in nailing down in his account-books the names of all those half-profits peasants who laboured and prayed to God and good fortune for him, and then swore like Turks when it came to reckoning day. "Mind what I am, not what I was once," says the proverb. Who he was, everybody knew, for his mother still did his house-cleaning. His Reverence had no family pride, no; and when he went to the baroness' to play at piquet with her, he had his brother to wait in the anteroom for him, holding the lantern.

His charity began at home, as God Himself enjoins; so he'd taken one of his nieces into his house, not bad-looking, but without a rag to her back, so that she'd never have found

the ghost of a husband; and he kept her and maintained her, what's more he put her in the fine room with glass in the windows, and the bed with bed-curtains, and he wasn't going to have her work, to ruin her hands with rough jobs. So that everybody thought it a real God's penalty when the poor creature was seized with scruples, such as will happen to women who have nothing else to do and pass their days in church beating their breasts because they're in mortal sin — though not when her uncle was there, for he wasn't one of those priests who like to show themselves on the altar in pomp and splendour before their inamoratas. As for other women, outside their homes it was enough for him to give them a little caress with two fingers on their cheek, paternally, or through the little window of the confession box to give them the benediction after they had rinsed out their consciences and emptied the sack of their own and other people's sins, by which means he always learned something useful, being a man who speculated in country produce.

Blessed Lord, he didn't pretend to be a holy man, not he! Holy men died of hunger, like the Vicar who celebrated mass even when he wasn't paid for it, and went round the beggarly houses in a cassock so tattered that it was a scandal to Religion. His Reverence wanted to get on, and he got on, with the wind full-sail, at first a little bit scuttling, because of that blessed frock which bothered him, so much so that for pitching it into the vegetable garden he had been had up before the Monastic Tribunal, and the confraternity had helped him to get the better of it, so as to be rid of him, because so long as he was in the monastery there were stools and dishes flying at every election of provincials; Father Battistino, a servant of God sturdy as a muleteer, had been half slaughtered, and Father Giammaria, the Superior, had lost all his teeth in the fray. His Reverence, himself, kept mum in his cell, after he'd stirred up the fire, and in that way he'd managed to become a *reverend*, with all his teeth, which were of good use to him; and everybody said to Father Giammaria, who had been the one to take this scorpion into their sleeve, "Good for him!"

But Father Giammaria, good soul, chewing his lips with

his bare gums, replied:

"Well, what do you want! He was never cut out for a Capucin friar. He's like Pope Sixtus, who started by being a swineherd and then became what he was. Didn't you see what promise he gave as a boy?"

And so Father Giammaria remained the superior of the Capucin friars, without a shirt to his back or a cent in his pocket, hearing confession for the love of God, and cooking vegetable-soup for the poor.

His Reverence, as a boy, when he saw his brother — the one with the lantern — breaking his back hoeing in the fields, and his sisters unable to find a husband even if they'd give themselves away for nothing, and his mother spinning worsted-yarn in the dark so as to save the floating-wick lamp, had said: "I want to be a priest!"

They had sold the mule and the scrap of land in order to send him to school, in the hope that if they got so far as to have a priest in the house, it would be better than the patch of land and the mule. But it took more than that to keep him at the Seminary. And so the boy began to buzz round the monastery for them to take him as a novice; and one day when they were expecting the provincial, and there was a lot to do in the kitchen, they called him in to lend a hand. Father Giammaria, who had a good heart, said to him: "You like it here? Then you stop with us."

And Brother Carmelo, the porter, in the long hours when he had nothing to do, wearying of sitting on the low wall of the cloister knocking his sandals one against the other, put together a bit of a frock for him out of the rags of cassocks which they'd flung on to the fig-tree to scare away the sparrows. His mother, his brother and his sister protested that if he became a friar it was all over with them, and they gave up the money that had gone for his schooling as lost, for they'd never get another halfpenny out of him. But he, who had it in his blood to be a friar, shrugged his shoulders and answered, "You mean to tell me a fellow can't follow the vocation God has called him to?"

Father Giammaria had taken a fancy to him because he was as light as a cat in the kitchen, and the same at all the

menial jobs, even in serving at mass, as if he'd never done anything else all his life long, with his eyes lowered and his lips sewed together like a seraph. Now that he no longer served at mass he still kept his lowered eyes and his sewed-up lips, when it was a question of some shady business with the gentry, or when there was occasion for him to bid in the auction of the communal lands, or to take his oath before the Magistrate.

He had to take a fat oath indeed, in 1854, at the altar, in front of the ark that holds the Sacrament, while he was saying the holy mass, and people were accusing him of spreading the cholera, and wanting to make him dance for it.

"By this consecrated host which I have in my hand," said he to the faithful who were kneeling, crouching low on to their heels, "I am innocent, my children! Moreover I promise you the scourge shall cease within a week. Have patience!"

Yes, they had patience; perforce they had patience! Since he was well in with the judge and the force-captain, and King Bomba sent him fat chickens at Easter and at Christmas, because he was so much obliged to him, they said; and Bomba had sent him also the counter-poison, in case there did come a serious accident.

An old aunt of his whom he'd had to take under his roof so as to prevent folks talking, and who was no good for anything any more except to eat the bread of a traitor, had uncorked the bottle for somebody else, and so had caught the cholera out and out; but her own nephew, for the fear of raising people's suspicions, hadn't been able to administer the counter-poison to her.

"Give me the counter-poison; give me the counter-poison!" pleaded the old woman, who was already as black as coal, without any regard for the doctor and the lawyer who were both there, looking one another in the face embarrassed. His Reverence, with his brazen face, as if it wasn't his affair, muttered, shrugging his shoulders, "Take no notice of her, she is delirious."

The counter-poison, if he really had got it, had been sent to him by the king under seal of confession, and he couldn't

give it to anybody. The judge himself had gone to beg it of him on his knees, for his wife who was dying, and he'd got nothing for answer from his Reverence except this:

"You may command me in life and death, dear friend; but in this business, I can do nothing for you."

This was the story as everybody knew it, and since they knew that by dint of intrigues and cleverness he had managed to become the intimate friend of the king, of the judge, and of the force-captain, and had managed to get a handle over the police, like the Intendant himself, so that his reports arrived at Naples without ever passing through the hands of the Lieutenant, nobody dared to fall out with him, and when he cast his eye upon an olive-garden or piece of tilled land that was for sale, or on a lot of the communal lands that was to be leased out by auction, even the big somebodies of the place, if they dared to bid against him, did it with smooth words and smarmy phrases, offering him a pinch of snuff. Once, with the baron himself, they kept on for half a day haffling and chaffling. The baron played the sugary, and his Reverence, seated in front of him with his gown gathered between his legs, at every higher bid offered him his silver snuff-box, sighing:

"Why, whatever are you thinking of, Baron, my dear sir? Now the donkey's fallen down, we've got to get him up again."

And so until the lot was knocked down, and the baron gave in, green with bile.

Which the peasants quite approved of, because big dogs always quarrel among themselves over a good bone, and there's never anything left for poor devils to gnaw. But what made them murmur again was that that servant of God squeezed them worse than the antichrist. Whenever they had to share with him, he had no scruple about laying hold of his neighbour's property, since he had all the implements of confession in his own hands, and if he fell into mortal sin he could give himself absolution by himself.

"Everything depends on having a priest in the house," they sighed. And the most well-to-do among them denied themselves the bread out of their mouths to send their son to

the Seminary.

"When a man goes into the field, he's got to go in altogether," said his Reverence as an excuse for himself when he had no regard for anybody. Even mass itself he wouldn't celebrate save on Sunday, when there was nothing else to do, for he wasn't one of your priest-johnnies who'd run round after the quarter-dollar for the mass. He wasn't in want. So that Monsignor the Bishop, in his pastoral visit, arriving in his house and finding his breviary covered with dust, wrote on it with his finger: "*Deo gratias!*" But his Reverence had something else to do but waste his time reading his breviary, and he laughed at Monsignor's reproof. If his breviary was covered with dust, his oxen were glossy, his sheep had deep fleeces, and his wheat stood as high as a man, so that his half-profits labourers enjoyed at least the sight of it, and could build fine castles in the air on it, before they came to reckon with the master. The poor devils opened their hearts like anything. Wheat standing like magic! The Lord must have passed by it in the night! You can see it belongs to a servant of God; and that it's good to work for him who's got the mass and the benediction in his hands!

In May, in the season when they looked up into the sky to conjure away any cloud that was passing, they knew that their master was saying mass for the harvest, which was worth more than the images of Saints, or the blessed seeds to drive away the evil eye or ill-fortune. So it was, his Reverence didn't want them to sow the blessed small-seed among the wheat, because it does no good except to attract sparrows and other mischievous birds. Of images of the saints however he had pocketfuls, since he took as many as he liked from the sacristy, good ones too, and gave them to his peasants.

But at harvest time he came on horseback, along with his brother, who served him as estate-keeper, with his gun on his shoulder, and then he never stirred, but slept there, in the malaria, to look after his own interests, without bothering even about Christ. Those poor devils, who had forgotten the hard days of winter in that fine weather, stood open-mouthed when they heard the litany of their debts being re-

cited to them. So many measures of beans which your wife came for in the time of the snow — so many bundles of kindling given to your boy — so many measures of corn advanced for seed, with interest at so much a month. — Makes the account!

A swindling account! In the year of scarcity, after Uncle Carmenio had left his sweat and his health in his Reverence's fields, he had to leave his ass as well, come harvest-time to pay off the debt, and went away himself empty-handed, swearing with awful words that made heaven and earth shudder. His Reverence, who wasn't there to confess him, let him say his say, and led the ass into the stable.

Since he had become rich he had discovered that his family, who had never even had bread to eat, possessed a benefice as fat as a canonry, and at the time of the abolishing of the mortmains, he had applied for the release and had definitely laid hands on the farm. Only he was annoyed at the money he had to pay for the release, and called the Government a thief for not letting the property of the benefices go gratis to those whom it belonged to.

On this score of the Government he had had to swallow a fair amount of bile, until 1860, when they had made the revolution, and he'd had to hide in a hole like a rat, because the peasants, all those who had had trouble with him, wanted to do him in. After that, had come the litany of the taxes, which there was no end to paying, and the very thought of it turned his wine at table into poison. Now they were setting on the Holy Father, and wanting to take away from him the temporal power. But when the Pope sent out the excommunication against all those who profited by the mortmains, his Reverence felt the fly settle on his own nose, and he grumbled:

"What's the Pope got to do with my property? He's got nothing to do with the temporal power." And he went on saying mass better than ever.

The peasants went to hear his mass, but without wishing it they thought of all the robberies of the celebrant, and were distracted. Their women, while they were confessing their sins to him, couldn't help letting out to his face:

"Father I accuse myself of having spoken ill of you who are a servant of God, because we've been without beans and without grain this winter, because of you."

"Because of me? Do I make good weather or bad luck? Or am I to own the land so that you lot can sow it and use it to your own advantage? Have you no conscience, and no fear of God? Why have you come here to confess yourself? This is the devil tempting you, to make you lose the sacrament of penitence. When you go and get all those children of yours you never think that they're so many mouths to feed? And what fault is it of mine if then there isn't enough bread for you? Did I make you get all those children? I became a priest so as not to have any."

However, he absolved them, because he was obliged to; but nevertheless in the heads of those rough people there still remained some confusion between the priest who raised his hand to bless in the name of God, and the master who falsified the accounts, and sent them away from the farm with their sack empty and their sickle under their arm.

"We can't do anything, we can't do anything," muttered the poor creatures resignedly. "The pitcher doesn't win against the stone, and we can't go to law with his Reverence, because it's he who knows the law."

He did know it too! When they were before the judge, with a lawyer, he stopped everybody's mouth with his saying: "The law is like this and like that." And it was always as it suited him. In the good days gone by he laughed at his enemies and his enviers. They had raised the deuce, they had gone to the bishop, they had thrown his niece in his face, Farmer Carmenio and ill-gotten gains, they had had mass and confession taken away from him. Very well! What then? He had no need either of bishop or anybody. He had his own possessions, and was respected like those who lead the band in the village; he was at home with the baroness, and the more row they made about him, the worse was the scandal. The big people are never touched, not even by the bishop, and you take your hat off to them, out of prudence and love of peace.

But after heresy had triumphed, with the revolution, what

good was all that to him? The peasants were learning to read and write, and could reckon up accounts better than you could yourself; the political parties were wrangling for the local government, and dividing the spoil without regard to the rest of the world; the first beggar that came along could find a gratuitous counsel, if he had a lawsuit with you, and he made you pay all the costs of the case yourself! A priest didn't count any more, neither with the judge, nor with the force captain; nowadays he couldn't even get a man put into prison on a mere hint, if they were wanting in respect to him, and he was no good any more except to say mass, and hear confession, like a public servant. The judge feared the newspapers and public opinion, what Caius and Sempronius might say, and he dispensed justice like Solomon! And then even the property he'd got together with the sweat of his own brow, they envied it him, they'd thrown the evil eye on him and black magic; that bit of nourishment he ate at table gave him a great to-do in the night; while his brother, who led a hard life and ate bread and onion, digested better than an ostrich, knowing that within a hundred years' time, when he himself was dead, he'd be his heir, and would find himself rich without lifting a finger. The mother, poor thing, was good for nothing more, and ony lived on to suffer and make others suffer, nailed down in bed with paralysis, so that she had to be waited on herself now; and his niece herself, fat, well-clad, provided with everything she could want, with nothing to do but to go into church, tormented him when she took it into her head to be in mortal sin, as if he was one of those excommunicated scoundrels who had dispossessed the pope, and she had made the bishop take away mass from him.

"There's neither religion, nor justice, nor anything left!" grumbled his Reverence as he grew to be old. "Now everybody wants to have his say. Those that have got nothing want to take what you've got from you. — 'You get up, so that I can take your place!' Those that have got nothing else to do come looking for fleas in your house! They wanted to make a priest no better than a sexton, say mass and sweep the church. They don't want to do the will of God any more,

that's where it is!"

SO MUCH FOR THE KING

NEIGHBOUR COSIMO, the litter driver had dressed down his mules, lengthened the halters a bit for the night, spread a handful of bedding under the feet of the bay mare, who had slipped twice on the wet cobblestones of the narrow street of Grammichele, after the heavy rain there had been, and then he'd gone to stand in the stable doorway with his hands in his pockets, to yawn in the face of all the people who had come to see the King, for there was such a thronging that day in the streets of Caltagirone that you'd have thought it was the festival of San Giacomo; at the same time he kept his ears open and his eye on his cattle, which were steadily munching their barley, so that nobody should come and steal them from him.

Just at the moment they came to tell him that the King wanted to speak to him. Or rather it wasn't the King who wanted to speak to him, because the King never speaks to anybody, but one of those through whose mouth the King speaks, when he has something to say; and they told him that His Majesty wanted his litter, next day at dawn, to go to Catania, because he didn't want to be obliged neither to the bishop, nor to the lieutenant, but preferred to pay out of his own pocket, like anybody else.

Neighbour Cosimo ought to have been pleased, because it was his business to drive people in his litter, and at that very time he was waiting for somebody to come and have his con-

veyance, and the King isn't one to stand and haggle for a dime more or less, like so many folks. But he would rather have gone back to Grammichele with his litter empty, it bothered him so much to have to carry the King in his litter, that the holiday all turned to poison for him at the mere thought of it, and he couldn't enjoy the illuminations any more, nor the band that was playing in the marketplace, nor the triumphal-car that was going round the streets, with the picture of the King and Queen, nor the church of San Giacomo all lit up, so that it was spitting out flames, and the Host was exposed inside, and the bells ringing for the King.

The grander the festival, the more frightened did he become of having to take the actual King in his litter, and all those squibs, that crowd, those illuminations and that clash of bells simply went to his stomach, so that he couldn't close his eyes all night, but he spent it in examining the shoes of the bay mare, curry-combing his mules, and stuffing them up to their throats with barley, to get their strength up, as if the King weighed twice as much as anybody else. The stables were full of cavalry soldiers, with huge spurs on their heels, which they didn't take off even when they threw themselves down to sleep on the planks, and on all the nails of the stable-posts were hung sabres and pistols so that it seemed to poor Uncle Cosimo that they were there to cut off his head, if by bad luck one of the mules should go and slip on the wet stones of the narrow street while he was carrying the King; and really there had poured such quantities of water out of the sky just on those particular days that the people must have been crazy mad to see the King, to come all the way to Caltagirone in such weather. For himself, sure as God's above, he'd rather have been in his own poor little house, where the mules were pinched for room in the stable, but where you could hear them munching their barley not far from the bed-head, and he'd willingly have paid the five-dollar piece which the King was due to fork out, to find himself in his own bed with the door shut and lying with his nose under the blankets, his wife busying herself around with the lamp in her hand, to settle up the house for the night.

At dawn the bugle of the soldiers ringing like a cock that

knows the time made him start from his doze, and put the stables into a turmoil. The wagoners raised their heads from the pole they had laid down for a pillow, the dogs barked, and the hostess put in an appearance from the hayloft, heavy with sleep, scratching her head. It was still dark as midnight, but people were going up and down the street as if it was Christmas night, and the hucksters near the fire, with their little paper lanterns in front of them, banged their knives on their benches to sell their almond-rock. Ah, how all the people who were buying toffee must be enjoying themselves at their festival, trailing round the streets tired and sleepy, waiting for the King, and as they saw the litter go by with its collar-bells jingling and its woollen tassels, they opened their eyes and envied Neighbour Cosimo who had seen the King face to face, while nobody else had had so much luck up till then, not in all the forty-eight hours that the crowd had been waiting day and night in the streets, with the rain coming down as God sent it. The church of San Giacomo was still spitting fire and flame, at the top of the steps that there was no end to, waiting for the King to wish him Godspeed, and all its bells were ringing to tell him it was time for him to be going. Were they never going to put out those lights; and had the sexton an arm of iron, to keep on ringing day and night? Meanwhile in the flat-lands of San Giacomo the ashen dawn had hardly come, and the valley was a sea of mist; and yet the crowd was thick as flies, with their noses in their cloaks, and the moment they saw the litter coming they wanted to suffocate Neighbour Cosimo and his mules, thinking the King was inside.

But the King kept them waiting a good bit still; perhaps at that moment he was pulling on his breeches, or drinking his little glass of brandy, to clear his throat, a thing that Neighbour Cosimo hadn't even thought of that morning, for his throat felt so tight. An hour later arrived the cavalry with unsheathed sabres, and made way. Behind the cavalry rolled another wave of people, and then the band, and then again some gentlemen, and ladies in little hats, their noses red with cold; and even the hucksters came running up, with their little benches on their heads, to set up shop again; to try to

sell a bit more almond toffee; so that in the big square you couldn't have got a pin in, and the mules wouldn't even have been able to shake the flies off, if the cavalry hadn't been there to make space; and so if you please the cavalry brought along with them a cloud of horseflies, those flies that send the mules in a litter right off their heads, so that Neighbour Cosimo commended himself to God and to the souls in purgatory every one he caught under the belly of his cattle.

At last the ringing was heard twice as loud, as if the bells had gone mad, and then the loud banging of crackers let off for the King, another flood of people came running up, and the carriage of the King appeared in sight, seeming to swim on the heads of the people in the midst of all that crowd. Then resounded the trumpets and drums, and the crackers began to explode again, till the mules, God save us, threatened to break the harness and everything, lashing out kicks; the soldiers drew their sabres, having sheathed them again, and the crowd shouted: "The Queen, the Queen! That little body there, beside her husband, you'd never believe it!"

But the King was a fine-built man, large and stout, with red trousers and a sabre hanging at his stomach; and he drew behind him the bishop, the mayor, the lieutenant, and another bunch of gentlemen in gloves and white handkerchiefs folded around their necks, and dressed in black so that they must have felt spiders running in their bones, in that bit of a north-wind that was sweeping the mist from the plain of San Giacomo. Now the King, before he mounted his horse, and while his wife was getting into the litter, was talking first to one then to another, as if it was no matter to him, and coming up to Neighbour Cosimo he clapped him on the shoulder, and told him just like this, in his Neapolitan way of talking, "Remember you are carrying your Queen!" — so that Neighbour Cosimo felt his legs sinking back into his belly, the more so that at that moment a frenzied cry was heard, the crowd swayed like a sea of ripe corn, and a young girl, still dressed like a nun and very pale, was seen to throw herself at the feet of the King and cry, "Pardon!" She was asking pardon for her father, who had been one of those who had had a hand in trying to pull the King down from the

38

throne, and had been condemned to have his head cut off. The King spoke a word to one of those near him, and that was enough for them not to cut off the head of the girl's father. And so she rose quite happy, and then they had to carry her away in a faint, she was so glad.

Which was as good as saying that the King with one word could have anybody's head he liked cut off, even Neighbour Cosimo's, if a mule in the litter should chance to stumble and throw out his wife, bit of a thing as she was.

Poor Neighbour Cosimo had all this before his eyes as he walked beside his bay mule with his hand on the shaft, and a bit of Madonna's dress between his lips, recommending himself to God as if he was at death's door, while all the caravan, with King, Queen and soldiers had started off on the journey amid the shouting and bell-ringing, and the banging of the cannon-crackers which you could still hear away down on the plain; and when they had come right down in the valley, on the top of the hill they could still see the black crowd teeming in the sun as if it was the cattle-fair in the plain of San Giacomo.

But what good did Neighbour Cosimo get from the sun and the fine day? If his heart was blacker than a thunder-cloud, and he didn't dare raise his eyes from the cobble-stones on which the mules put down their feet as if they were walking on eggs; nor could he look round to see how the corn was coming on, nor enjoy seeing the clusters of olives hanging along the hedges, nor think of what a lot of good all last week's rain had done, while his heart was beating like a hammer at the mere thought that the torrent might be swollen, and they had got to cross the ford! He didn't dare to seat himself straddle-legs on the shafts, as he always did when he wasn't carrying his Queen, and snatch forty winks under that fine sun and on that level road that the mules could have followed with their eyes shut; whilst the mules, who had no understanding, and didn't know what they were carrying, were enjoying the dry level road, the mild sun and the green country, wagging their hind-quarters and shaking the collar-bells cheerfully, and for two pins they would have started trotting, so that Neighbour Cosimo had his heart in his

mouth with fright merely seeing his creatures growing lively, without a thought in the world neither for the Queen or anything.

The Queen, for her part, kept up a chatter with another lady, whom they'd put in the litter to while away the time with her, in a language of which nobody understood a single damn; she looked round at the country with her eyes blue as flax flowers, and she rested a little hand on the window-frame, so little that it seemed made on purpose to have nothing to do; and it certainly wasn't worth while having stuffed the mules with barley to carry that scrap of a thing, Queen though she was! But she could have people's heads cut off with a single word, small though she might be, and the mules, who had no sense in them, what with that light load, and all that barley in their bellies, felt strongly tempted to start dancing and jumping along the road, and so get Neighbour Cosimo's head taken off for him.

So that the poor devil did nothing all the way but recite pasternosters and ave marias between his teeth, and beseech the souls of his own dead, those whom he knew and those whom he didn't know, until they got to Zia Lisa, where a great crowd had gathered to see the King, and in front of every hole of a tavern there was their own side of pork skinned and hung up for the feast. When he got home at last, after having delivered the Queen safe and sound, he couldn't believe it was true, and he kissed the edge of the manger as he tied up his mules, then he went to bed without eating or drinking, and didn't even want to see the Queen's money, but would have left it in his jacket pocket for who knows how long, if it hadn't been for his wife who went and put it at the bottom of the stocking under the straw mattress.

His friends and acquaintances, curious to know how the King and Queen were made, came to ask him about the journey, pretending they had come to enquire if he had caught malaria. But he wouldn't tell them anything, feeling himself in a fever again at the very mention of it, and the doctor came morning and evening, and charged him about half of that money from the Queen.

Only many years later, when they came to seize his mules

in the name of the King, because he couldn't pay his debts, Neighbour Cosimo couldn't rest for thinking that those were the very mules which had brought his wife safe and sound — the King's wife, that is — poor beasts; and in those days there were no carriage-roads, so the Queen would have broken her neck if it hadn't been for his litter, and people said that the King and Queen had come to Sicily on purpose to make the roads, and still there weren't any yet, which was a dirty shame. But in those days litter-drivers could make a living, and Neighbour Cosimo would have been able to pay his debts, and they wouldn't have seized his mules, if the King and Queen hadn't come to make the high-roads.

And later, when they took away his Orazio, whom they called Turk, because he was so swarthy and strong, to make him an artilleryman, and that poor old woman of a wife of his wept like a fountain, there came to his mind again that girl who had come to throw herself at the feet of the King crying, "Pardon!" — and the King had sent her away happy with one word. Nor could you make him understand that there was another King now, and that they'd kicked out the old one. He said that if the King had been there, he'd have sent him away happy, him and his wife, because he had patted him on the shoulder, and he knew him and had seen him face to face, with his red trousers and his sabre hung at his stomach, and with a word he could have people's heads cut off, and send to seize mules into the bargain, if anyone didn't pay his debts, and take the sons for soldiers, just as he pleased.

DON LICCIU PAPA

THE GOODWIVES were spinning in the sun, and the fowls were scratching among the rubbish in front of the doorsteps, when suddenly there arose a squealing and a scampering all down the little street, as Uncle Maso was seen approaching from the distance, Uncle Maso the pig-snatcher, with his noose in his hand; and all the fowls scuttled away squawking, as if they knew him.

Uncle Maso got a dime from the Town Council for every fowl, and half-a-dollar for every pig which he caught breaking the by-laws. He preferred the pigs. Therefore, seeing Goodwife Santa's little porker stretched out peacefully with its nose in the mire, he threw the running noose round its neck.

"Oh holy, holy Madonna! What are you doing, Uncle Maso?" cried Aunt Santa, pale as death. "For Mercy's sake, Uncle Maso, don't have me fined, it'll be the finish of me!"

Uncle Maso, the traitor, in order to gain time to get the young pig on to his shoulders, began to reel off pretty speeches to her.

"My dear good woman, what am I to do? It's the Town Council's orders. They won't have pigs in the street any more. If I leave you this young sow I lose my own daily bread."

Aunt Santa ran behind him like a madwoman, her hands clutching her hair, screaming all the time:

"Ah, Uncle Maso! don't you know she cost me a dollar at

the fair of San Giovanni, and I care for her like the apple of my eye! Leave me my little pigs, Uncle Maso, by the soul of those that are dead and gone! Come the New Year, with God's help she'll be worth seven dollars!"

Uncle Maso, with never a word, his head dropped and his heart as hard as a stone, only minded where he put his feet, so as not to slip in the muck; the young pig over his shoulder twisting up to heaven and grunting. Then Aunt Santa, desperate, in order to save her pig fetched him a solemn kick in the rear, and send him rolling.

The goodwives no sooner saw the pig-snatcher sprawling in the mud than they were upon him with their distaffs and their wooden-soled slippers eager to pay him out for all the pigs and fowls he had on his conscience. But at that moment up ran Don Licciu Papa with his sword-belt over his paunch, bawling from the background like one possessed, keeping out of reach of the distaffs.

"Clear the way! Clear the way for the Law!"

The law condemned Goodwife Santa to pay the fine and the costs, and in order to save her from prison they had to turn for protection to the baron, whose kitchen window looked on to the little street, and who rescued her by a miracle, demonstrating to the Court that it was not an instance of rebellion, because that day the pig-snatcher hadn't got his cap on with the Town-Council badge.

"You see now!" exclaimed the women in chorus. "It takes a saint to get into Paradise! Who was to know that about the cap?"

However, the baron wound up with a sermon: Those pigs and fowls had got to be cleared out of the street; the Town Council was quite right, the place was a pig-sty.

After that, every time the baron's man-servant emptied his dust-pan into the street, on the heads of the neighbours, not a woman murmured. Only they lamented that the hens, shut up in the house to escape the fine, didn't rear good chicks any more; and the pigs, tied by the leg to the bedpost, were like souls tortured in purgatory. Anyhow they used to sweep their streets themselves, before.

"All that muck would be so much gold for the

grasshopper closes," sighed Farmer Vito. "If I'd got my bay mule yet, I'd wipe up the street with my own hands."

And this also was a bit of Don Licciu Papa's work. He had come with the bailiff to seize the mule for debt since Farmer Vito would never have let the bailiff by himself take the mule from the stable, no not if they'd killed him for it, he wouldn't, he'd rather have bitten off the fellow's nose and eaten it like bread. Then before the judge, who sat at the table like Pontius Pilate, when Farmer Venerando prosecuted him to recover the loan advanced on the half-profits, he couldn't find a word to say. The grasshopper closes were fit for nothing but grasshoppers; the fool was himself, and had himself to blame if he'd come home from harvest empty-handed, and Farmer Venerando was quite right to want to be paid back, without all that talking and spinning things out, though that was what he'd paid a lawyer to talk for him for. But when it was over, and Farmer Venerando was going off gleefully, rocking inside his great boots like a fattened duck, he couldn't help asking the clerk if it was true that they were going to sell his mule.

"Silence!" interrupted the judge, who was blowing his nose before passing on to another case.

Don Licciu Papa woke up with a start on his bench, and cried, "Silence!"

"If you'd brought a lawyer, they'd have let you say something more," Neighbour Orazio told him for his comfort.

In the Piazza, in front of the Town Hall steps, the crier sold his mule for him.

"Forty dollars for Neighbour Vito Gnirri's mule! Forty dollars for a fine bay mule! Forty dollars!"

Neighbour Vito, sitting on the steps with his chin between his hands, wasn't going to let out a word about the mule's being old, and it's being over sixteen years that he'd worked her. And she stood there as happy as a bride, in her new halter. But the moment they'd really led her away, he went off his head, thinking of that usurer of a Farmer Venerando who was getting forty dollars out of him just for one year's half-profits on the grasshopper closes, and the land wasn't

47

worth as much to buy it outright, and without his mule he'd never be able to work it, and next year he'd be in debt again. And he began to shout like a maniac into Farmer Venerando's face:

"What shall you want of me when I've got nothing left? — Antichrist that you are!"

And he'd have liked to knock the baptism off his brow, if it hadn't been for Don Licciu Papa who was there with his sword and his braided hat, and who began to shout as he drew back:

"Halt in the Law's name! Halt in the Law's name!"

"What Law!" squealed Neighbour Vito going home with the halter in his hand. "Law is made for them who've got money to spend."

Which was what the herdsman Arcangelo knew, who, when he'd gone to Law with his Reverence because of his bit of a house which his Reverence wanted to force him to sell to him, had everybody saying to him:

"Are you out of your mind going to Law with his Reverence? It's the tale of the pitcher fighting with the stones. His Reverence with all his money will hire the best lawyer's tongue among them, and will bring you to poverty and craziness."

His Reverence, since he'd got rich, had enlarged the paternal house, this way and that, like the hedgehog does when he swells himself out to drive his neighbours away from his hole. Now he'd widened the windows looking on to Shepherd Arcangelo's roof, and he said he needed the other man's house so as to build a kitchen above it and turn the window into a doorway.

"You see, my dear Neighbour Arcangelo, I can't manage without a kitchen! You must be reasonable!"

Neighbour Arcangelo didn't see it, and kept on saying he wanted to die in the house where he was born. As a matter of fact, he only came there of a Saturday; but the stones knew him, and if he thought of the village, when he was away on the wild pastures of Carramone, he never saw it as anything except that patched-up little doorway and that window without any glass.

"All right, all right," said his Reverence to himself. "Pig-headed peasants! We've got to knock the sense in."

And from his Reverence's window rained down broken pots, stones and dirty water on Shepherd Arcangelo's roof, till the corner where the little bed stood was worse than a pigsty. If Shepherd Arcangelo shouted, his Reverence began to shout louder than he, from the roof above: Couldn't one keep a pot of basil on his window-sill nowadays? Wasn't a man free to water his own flowers?

Shepherd Arcangelo had a head stubborner than his own wethers, and he went to Law. There came the judge, the clerk, and Don Licciu Papa, to see whether a man was free to water his own flowers or not, so of course on that day the flowers weren't there on the window-sill, and his Reverence had only to take the trouble to remove them every time the Law was coming, and put them out again as soon as they'd turned their backs. As for the judge he couldn't spend his days playing watchman on Shepherd Arcangelo's roof, or patrolling up and down the narrow street; every visit he made was expensive.

Remained only to decide whether his Reverence's window should or should not have an iron grating, and the judge, the clerk and all the lot looked up with their spectacles on their noses, and took measurements so that you'd have thought it was a baron's roof, that bit of a flat mouldy housetop. And his Reverence brought forth certain ancient rights for a window without a grating, and for a few tiles which projected out over the roof, till you could make nothing of it any more, and poor Shepherd Arcangelo himself stared up in the air as if to find out whatever his roof could be guilty of. He lost his sleep at nights and the smile from his mouth; he bled himself in expenses, and had to leave his flock in charge of the boy while he ran round after the judge and the bailiff. So of course the sheep began to die like flies, with the first cold of winter, which showed that the Lord was punishing him for falling out with the Church, so they said.

"Then you take the house," he said at last to his Reverence, when after so much law-suits and expenses they wouldn't even advance him the money to buy a rope to hang

himself from one of the beams. He wanted to sling his saddlebag over his neck and go off with his daughter to live with the sheep, for he didn't want to see that accursed house again, while the world stood.

But then his other neighbour the baron came forward, saying that he too had windows and lean-to tiles above the roof of Shepherd Arcangelo, and seeing that his Reverence wanted to build a kitchen, he himself had to enlarge his store-pantry, that the poor goat-herd no longer knew whom his house did belong to. But his Reverence found the means to settle the quarrel with the baron, dividing the house of Shepherd Arcangelo between them like good friends, and seeing that the latter had this other obligation as well, the price of the house was reduced by a good quarter.

Nina, the daughter of Shepherd Arcangelo, when they had to leave the house and depart from the Village, simply never stopped crying, as if her heart was fastened to those four walls and to the nails of the partitions. Her father, poor fellow, tried to console her as best he could, telling her that away up there, in the Caves of Carramone, you lived like a prince, without neighbours and pig-snatchers. But the good-wives who knew the story winked among themselves, murmuring:

"Up at Carramone the young Master won't be able to come to her, at evening, when Neighbour Arcangelo is with his sheep. That's why Nina is weeping like a fountain."

When Neighbour Arcangelo got to know this he began to swear and shout:

"Hussy! Now who'll you get to marry you?"

But Nina wasn't thinking of getting anybody to marry her. She only wanted to stop where the young Master was, so that she could see him every day at the window, as soon as he got up, and make him a sign to ask him if he was coming to see her that evening. And in this way Nina had fallen, with seeing the young Master at the window every day, who had begun by laughing to her, and sending her kisses and the smoke from his pipe, and the neighbour women were bursting with jealousy. Then bit by bit love had come, so that now the girl had quite lost her senses, and she said straight and

flat to her father:

"You go where you like. I shall stop where I am."

And the young Master had promised her he would look after her.

Shepherd Arcangelo wasn't swallowing that, and he wanted to fetch Don Licciu Papa to take away his daughter by force.

"Anyhow when we've gone from here nobody will know our shames," he said. But the judge told him that Nina had already reached years of discretion, and she was her own mistress to do as she pleased and chose.

"Ah! her own mistress?" stammered Shepherd Arcangelo. "And I'm master!" And the first time he met the young Master, who blew smoke into his nose, he cracked his head like a nut with a wooden cudgel.

After they had tied him up fast, Don Licciu Papa came running up shouting: "Make way! Make way for the Law!"

They even gave him a lawyer to defend him before the judge.

"At least the Law will cost me nothing this time," said Neighbour Arcangelo. The lawyer succeeded in proving that four and four make eight, that Shepherd Arcangelo hadn't done it on purpose, wilfully seeking to murder the young Master with a cudgel of wild pear-wood, but that the cudgel belonged to his profession, and was used by him to knock the rams on the head when they wouldn't hear reason.

So he was only condemned to five years, Nina remained with the young Master, the baron enlarged his store-pantry, and his Reverence built a fine new house above that old place of Shepherd Arcangelo's, with a balcony and two green windows.

THE MYSTERY PLAY

THE MYSTERY PLAY

EVERY time he told this tale again, big tears came to Uncle Giovanni's eyes, which seemed quite incredible in his policeman's face.

They had set up the theatre in the little square in front of the church: myrtle, oak, and entire branches of olive with all the foliage, showing that nobody had refused to let them take what they wanted for the Mystery Play.

Uncle Memmu, seeing the sexton in his orchard hacking and breaking off whole branches, fairly felt the blows of the hatchet in his stomach and called to him from the distance:

"Nay, aren't you a Christian, Neighbour Calogero, or has the priest never marked you with the holy oil, seeing that you lash at that olive tree without mercy?"

But his wife, really with tears in her eyes, kept trying to calm him down: "It's for the Mystery Play; leave him alone. The Lord will send you a good year for it. Don't you see the young corn dying of thirst?"

Quite yellow, green-yellow like children when they're sick, poor corn! and the earth as white and hard as a crust, eating it away, so that it made your throat burn to look at it.

"This is all Don Angelino's doing," grumbled her husband, "to get his supply of kindling, and lay hands on the offerings money."

Don Angelino the curate had worked like a navvy for a week, with the sexton to help, digging holes, erecting posts, hanging up redpaper lanterns, spreading for a background

the new curtains belonging to Farmer Nunzio, who had just got married, which made a fine show among the foliage, with the red lanterns in front.

The play was the Flight into Egypt, and the part of Holy Mary was to be played by Neighbour Nanni, who was a small-made man and had had himself clean shaved for the occasion. The moment he appeared, carrying the Infant Jesus at his breast, the latter being Goodwife Menica's little lad, and said to the robbers: "Behold my blood!" the people in the audience began to beat their breasts with stones, and started crying all in one voice, "Have mercy on us, Holy Virgin!"

But Janu and Master Cola, the robbers, in false beards made of lamb's skin, took no heed, and insisted on seizing the Sacred Child, to carry him off to Herod. The curate had chosen those two well, for robbers. Real stony-hearted villains they were! — so that Pinto, when he had a lawsuit with Neighbour Janu about the fig-trees in the vegetable garden, threw it up at him all that while after, saying: "You are the robber in the Flight into Egypt, you are."

Don Angelino, with the paper in his hand, kept repeating behind Farmer Nunzio's curtain: "In vain, oh woman, is your prayer; pity does not move me! Pity does not move me! — It's your turn Neighbour Janu." For those two scoundrels had clean forgotten their part, good-for-nothing lot that they were! The Virgin Mary had to go on begging and beseeching them, while folks were muttering in the crowd: "Neighbour Nanni only plays the softy because he's dressed-up as Holy Mary. But for that he'd stick the pair of them with that sheath-knife he's got in his pocket."

But as Saint Joseph came on to the scene, with his white cotton beard, going round seeking for his wife in the forest that came up to his breast, the crowd couldn't keep quiet, because the robbers and the Madonna and Saint Joseph could all have touched one another with their hands, if it hadn't been that the Mystery Play said they'd got to go circling round after one another without meeting. And this was the miracle. If the malefactors managed to lay hold of the Madonna and Saint Joseph, both together they'd made mince-

meat of them, and of the Infant Jesus as well, God preserve us!

Goodwife Filippa, whose husband was in the galleys for having slaughtered his neighbour in the vineyard with his hoe, because the fellow was stealing his prickly pears, wept like a fountain seeing Saint Joseph chased by robbers worse than a rabbit, and thought of her husband, when he had come to the little hut in the vineyard absolutely spent, with the police at his heels, and had said to her:

"Give me a drop of water. I'm done for!"

Then they had handcuffed him like Jesus in the garden, and shut him up in the iron cage, to try him, with his bonnet between his hands and his hair absolutely gone like a grey old wig with so many months of prison — you could see it in his eyes as well — as he listened to the judges and witnesses with his yellow prison-face. And when they had taken him away by sea, on which he had never been before, with his basket over his shoulder, linked up to his galley-companions like a string of onions, he had turned round to look at her for the last time, ah with such a face, for he would never see her again, for from the sea nobody ever comes back, and she had never heard any more of him.

"Ah Mother of Sorrows, you know where he is now!" mumbled the live man's widow as she knelt sitting back on her heels, praying for the poor wretch till she fancied she could see him, there, far off, in the dark. She alone could know what anguish there must be in the heart of the Madonna, at that moment when the robbers were just on the point of seizing Saint Joseph by his cloak.

"Now you see the meeting of the Patriarch Saint Joseph with the malefactors!" said Don Angelino wiping the sweat from his face with his pocket-handkerchief. And Trippa the butcher beat on the big drum — Zum! zum! zum! — to make them understand that the robbers were struggling with Saint Joseph. The goodwives began to scream, and the men picked up stones to flatten the snouts of those two rascals of Janu and Neighbour Cola, shouting, "Leave the patriarch Saint Joseph alone! you pair of villains!" And Farmer Nunzio, for love of his curtains, also started yelling that they

were not to burst it. Don Angelino then poked his head out of his den, with his chin unshaved for a week, and worked himself to death trying with hands and voice to calm them:

"Let them be! Let them be! That's how it's written in their part."

A fine part he'd written for them, indeed! and he said moreover it was all his own invention. Really, he would have put Christ on the cross with his own hands, to get the quarter for the mass. Or Neighbour Rocco, a father of five children, hadn't he had him buried without a scrap of a funeral, because he couldn't fleece anything from him — there, under the stone floor of the church, at night, in the dark, so that you couldn't even see to lower him into the vault, for eternity! And hadn't he turned Uncle Menico out of his little house, and taken it from him, because it was built on the rock-slope belonging to the church, and had a tithe-rent of a quarter a year on it, which Uncle Menico had never managed to pay? When he had built the cabin for himself, pleased as could be, carrying the stones with his own hands, it never entered his head that one day the curate would have it sold becaue of those five nickels tithe-rent. The difficulty was to get them together all at once when the tithes were due, and Don Angelino answered him, shrugging his shoulders:

"What am I to do? You see, brother, it's not my property, it's church property." Just like Master Calogero the Sexton, who repeated: "Serve the altar, and the altar will give you bread." Now he had hitched himself on to the rope in the belfry and was ringing for all he was worth, while Trippa was beating on the big drum, and the women were yelling, "Miracle! Miracle!"

Here Uncle Giovanni felt the hair rise on his head, as he remembered.

Just a year later, day for day, on the eve of Good Friday, Nanni and Master Cola met in the same place, at night, under the Easter moon, so that it was light as day in the small square. Nanni was squatting behind the church-tower, to catch anyone who was going to visit Gossip Venera, whom he had once or twice caught all in a fluster with her dress undone and had heard someone making off through the garden

gate.

"Who was here with you? You'd better tell me. If you like somebody else, I'll leave you to it, and goodnight to the music. But you know, I don't like to have such a thing on my mind."

She protested it wasn't true, swore by the soul of her husband, and called the Lord and the Madonna hung at the bedhead to witness, and kissed with crossed hands that very same light blue cotton petticoat that she had lent to Neighbour Nanni to act the Virgin Mary.

"Be careful! Be careful what you say to me!"

He didn't know that Mistress Venera had been smitten by Master Cola when she saw him playing the robber in the Mystery Play, with his lambswool beard.

"Oh, all right," he now thought to himself. "If that's the case there's nothing to do but to lie in wait for the rabbit, like a hunter, to make sure with one's own eyes."

The woman had said to the other man: "Look out for Neighbour Nanni. He's got something into his head, by the way he looks at me, and the way he hunts round the house every time he comes."

Cola had his mother depending on him, depending for her life on his earnings, so he didn't risk going to Gossip Venera's again — not for one day, two days, three days, nor till the devil tempted him with that moon which came in right to the bed through the cracks in the window frame, and made him have before his eyes all the time the little deserted street, and the widow's housedoor, at the turning of the small square facing the church-tower. Nanni was waiting in the shadow, alone in the square that was all white under the moon, and in a silence such that you could hear the clock of Viagrande chime every quarter of an hour, and the light trotting of the dogs which went sniffing in every corner and rummaging their noses in the street-sweepings. At last a footstep was heard, someone keeping close to the wall, and stopping at the widow's door, to knock softly, once, twice, then more quickly and in a hurry, like someone whose heart beat with desire and fear, and Nanni felt the stranger's knocking strike in his own chest too. Then the door opened

gradually, carefully, with a gap darker than the shadow, and a gun went off.

Master Cola fell, crying, "Mother, oh mother! They're killing me!"

No one heard or said anything, for fear of the law; even Gossip Venera herself said she was asleep. Only the mother, hearing the gunshot, felt herself struck through the bowels, and ran just as she was to pick up Cola at the widow's door, crying: "My son! My son!" The neighbours appeared with lights, and the only door that remained shut was the one in front of which the desperate mother continued her imprecations: "Vile woman! Vile woman! You've killed my child for me!"

The mother, on her knees beside her wounded son's bed, prayed to God, clasping her hands hard, her eyes quite dry, so that she looked like a madwoman. "Lord! Lord! My son, Lord!" Ah, what a cruel Easter the Lord had sent her. Exactly on Good Friday, while the procession was passing, with the drum and Don Angelino crowned with thorns! Ah, how black everything was in that house, and through the open door you could see the sun and the beautiful young cornfields, for that year the folks hadn't had to pray to God for a good season, and so they left Don Angelino to whip himself on the back with the scourge by himself; even when the sexton had gone to get in kindling, pretending it was for the Mystery play, they had threatened to lame him with stones if he didn't clear out quick.

Only in her house there was weeping, now that everybody was content! Only in her house! She was kept down by the side of that poor bed like a bundle of rags, broken, become all at once decrepit, her grey hair hanging about her face. And she heard none of those who filled the room out of curiosity. She saw nothing but the dulled eyes of her child, and pinched his nose. They had fetched the doctor to him; and they had brought Goodwife Barbara, the lucky-woman, and the poor mother had contrived to find the twenty-five cents to have Don Angelino say a mass for him.

The doctor shook his head. "It'll take more than Don Angelino's mass," said the goodwives. "You want the bles-

sed cotton of Fra Sanzio the hermit, or else the candle of the Madonna of Valverde, which performs miracles all over the place."

The wounded man, with the blessed cotton on his abdomen, and the candle before his yellow face, opened wide his dimmed eyes, looking at the neighbours one after the other, and tried to smile at his mother, with his pale lips, to let her know that he was really feeling better, with that miraculous cotton on his stomach. He nodded with his head, with that sad, sad smile of a dying man who says he feels better. The doctor however said no; that he wouldn't live the night through. And Don Angelino, not to have the value of his goods run down, repeated:

"It takes faith to perform miracles. Saints, and relics, and the blessed cotton are all excellent things when you have faith."

The poor mother had plenty of faith, she spoke really heart to heart with the saints and the Madonna, and said to the blessed candle, rapidly, quickly, through her shut teeth: "Lord! Lord! Grant me this mercy! Leave me my child, Lord!" And her son listened, intent, with his eyes fixed on the candle, and he tried to smile, to nod and say yes, he did.

All the village crazy to know the ins and outs of that deed; but the only one who was in the know was Mrs. Venera. As for her she might have been deeper in than ever if she had had to reckon with the blood that was found in the square, for Master Cola, gasping and staggering, had gone to fall precisely in the place where he'd played the robber in the Mystery Play the year before. However Mrs. Venera had to leave the village, because nobody would buy her breadcakes any more, and they called her the "excommunicated woman." Neighbour Nanni also lived on for a time, lurking here and there among the rocks and the fields, but at the first cold of winter they caught him one night near the first houses of the village, where he was waiting for the boy who used to bring him bread in secret. They tried him and sent him beyond the sea, to be with the husband of Goodwife Filippa.

Well for him, if he had never thought of putting on the

"excommunicated woman's" petticoat to play the Blessed
Virgin.

MALARIA

AND you feel you could touch it with your hand — as if it smoked up from the fat earth, there, everywhere, round about the mountains that shut it in, from Agnone to Mount Etna capped with snow — stagnating in the plain like the sultry heat of June. There the red-hot sun rises and sets, and the livid moon, and the *Puddara* which seems to float through a sea of exhalations, and the birds and the white marguerites of spring, and the burnt-up summer; and there the wild-duck in long black files fly through the autumn clouds, and the river gleams as if it were of metal, between the wide, lonely banks, that are broken here and there, scattered with pebbles, and in the background the Lake of Lentini, like a mere, with its flat shores, and not a boat, not a tree on its sides, smooth and motionless. By the lake-bed the oxen pasture at will, forlorn, muddied up to the breast, hairy. When the sheep-bell resounds in the great silence, the wag-tails fly away, noiselessly, and the shepherd himself, yellow with fever, and white as well with dust, lifts his swollen lids for a moment, raising his head in the shadow of the dry reeds.

And truly the malaria gets into you with the bread you eat, or if you open your mouth to speak as you walk, suffocating in the dust and sun of the roads, and you feel your knees give way beneath you, or you sink, discouraged on the saddle as your mule ambles along, with its head down. In vain the villages of Lentini and Francoforte and Paternò try to clamber

up like strayed sheep on to the first hills that rise from the plain, and surround themselves with orange groves, and vineyards, and evergreen gardens and orchards; the malaria seizes the inhabitants in the depopulated streets, and nails them in front of the doors of their houses whose plaster is all falling with the sun, and there they tremble with fever under their brown cloaks, with all the bed-blankets over their shoulders.

Down below, on the plain, the houses are rare and sad-looking, beside the roads wasted by the sun, standing between two heaps of smoking dung, propped up by dilapidated sheds, where the change-horses wait with extinguished eyes, tied to the empty manger. Or by the shore of the lake, with the decrepit bough of the inn sign hung over the doorway, the great bare room, and the host dozing squatted on the door-step, with his head tied up in a kerchief, spying round the deserted country ever time he wakes up, to see if a thirsty traveller is coming. Or else what looks like little huts of white wood, plumed with four meagre, grey eucalyptus trees, along the railway that cuts the plain in two like a hatchet cleft, where the locomotive flies whistling as the autumn wind, and where at night are coruscations of fiery sparks. Or finally here and there, at the boundaries of the farm-lands marked by a little stone pillar very roughly squared, the farm-places with their roofs shoved up from outside, with their door-frames collapsing, in front of the cracked threshing floors, in the shade of the tall ricks of straw where the hens sleep with their heads under their wing, and the donkey lets his head hang, with his mouth still full of straw, and the dog rises suspiciously, and barks hoarsely at the stone which falls out from the plaster, at the fire-fly which flickers past, as the leaf which stirs in the inert countryside.

At evening, as soon as the sun sinks, sun-burnt men appear in the doorways, wearing big straw hats and wide canvas drawers, yawning and stretching their arms; and half-naked women, with blackened shoulders, suckling their babies that are already pale and limp, so that you can't imagine that they'll ever get big and swarthy and romp on the grass when winter comes again, and the yard-floor will be

green once more, and the sky blue and the country all round laughing in the sun. And you can't imagine where all the people live who go to mass on Sundays, or why they live there, all those who come to the little church surrounded by cactus hedges, from ten miles around, from as far as ever the clanging of the little cracked bell can be heard over the endless plain.

However, wherever there is malaria there is earth blessed by God. In June the ears of wheat hang weighted down, and the furrows smoke as if they had blood in their veins the moment the ploughshare enters them in November. And then those who reap and those who sow must fall like ripe ears as well, for the Lord has said, "In the sweat of thy brow shalt thou eat bread." And when the sweats of fever leave some one of them stiff upon the mattress of maize-sheathes, and there's no need any more of sulphate or of decoction of eucalyptus, they put him on the hay-cart, or across an ass' pack-saddle, or on a ladder, or any way they can, with a sack over his face, and they take him to bury him by the lonely little church, under the thorny cactuses whose fruit no one for that reason eats. The women weep in a cluster, and the men stand looking on, smoking.

So they had carried away the estate-keeper of Valsavoia, who was called Farmer Croce, after he'd been swallowing sulphate and eucalyptus decoction for thirty years. In spring he was better, but at autumn, when the wild-ducks passed again, he put his kerchief on his head and showed himself not oftener than every other day in the doorway; till he was reduced to skin and bone, and had a big belly like a drum, so that they called him the Toad, partly because of his rude, savage manner, and partly because his eyes had become livid and stuck out of his head. He kept on saying before he died, "Don't you bother, the master will see after my children!" And with his wondering eyes he looked at them one after another in the face, all those who stood round the bed, the last evening, when they put the candle under his nose. Uncle Menico the goat-herd, who understood those things, said that his liver must be as hard as stone and weighed five pounds. But somebody added:

"Well, now he needn't worry about it! He's got fat and rich at his master's expense, and his children don't stand in need of anybody! Do you think he took all that sulphate and put up with all that malaria for thirty years, just to please his master?"

Neighbour Carmine, the host by the lake, had lost all his five children one after the other in the same way, three boys and two girls! Never mind about the girls! But the boys died just when they were getting old enough to earn their bread. So now he was used to it; and as the fever got the last boy under, after having harassed him for two or three years he didn't spend another farthing, neither for sulphate nor for decoctions, but drew off some good wine and set himself to make all the good fish stews he could think of, to provoke the appetite of the sick youth. He went fishing specially in the mornings, and came back laden with mullet and eels as thick as your arm, and when it was ready he stood before the bed with tears in his eyes and said to his son, "There you are, eat that!" And the rest of the fish Nanni the carter took to town to sell.

"The lake gives, and the lake takes away," said Nanni, seeing Neighbour Carmine weeping in secret. "What's the good, brother?"

The lake had given him good wages. And at Christmas, when eels fetch a good price, they used to have merry suppers before the fire, in the house by the lake, macaroni, sausages, everything you could think of, while the wind howled outside like a wolf that is cold and hungry. And in that way those that were left behind consoled themselves for the ones that were dead. But little by little they were wasting away, so that the mother grew bent like a hook with heart-brokenness, and the father, who was big and fat, was always on the doorstep, so that he needn't see those empty rooms, where his boys used to sing and work. The last one absolutely didn't want to die, and cried and grew desperate when the fever seized him, and even went and threw himself into the lake out of fear of death. But his father could swim, and fished him out again, and shouted at him that that a cold bath would bring back the fever worse than ever.

"Ah," sobbed the youth, clutching his hair with his hands, "there's no hope for me, there's no hope for me!" "Just like his sister Agatha, who didn't want to die because she was a bride," observed Neighbour Carmine in private to his wife, sitting on the side of the bed; and she, who for some time now had left off weeping, nodded assent, bent as she was like a hook.

But she, though she was so reduced, and her big fat husband, they both had tough skins, and lived on alone to mind the house. The malaria doesn't finish everybody. Sometimes there's one who will live to be a hundred, like Cirino the simpleton, who had neither king nor kingdom, nor wit nor wish, nor father nor mother, nor house to sleep in, nor bread to eat, and everybody knew him for forty miles around, since he went from farm to farm, helping to tend the oxen, to carry the manure, to skin the dead cattle, and do all the dirty jobs; and got kicks and a bit of bread; he slept in the ditches, on the edges of the fields, under the hedges, or under the sheds for the standing cattle; and lived by charity, straying round like a dog without a master, with two ends of old drawers held together with bits of string on his thin black legs; and he went singing at the top of his voice under the sun which beat down on his bare head, yellow as saffron. He neither took sulphate any more, nor medicines, nor did he catch the fever. A hundred times they had found him stretched out across the road, as if he was dead, and picked him up; but at last the malaria had left him, because it could do no more with him. After it had eaten up his brain and the calves of his legs, and had got into his belly till it was swollen like a water bag, it had left him as happy as an Easter Day, singing in the sun better than a cricket. The simpleton liked best to stand in front of the stables at Valsavoia, because people passed by, and he ran after them for miles, crying, "Uuh! uuh!" until they threw him a few cents. The host took the cents from him and kept him to sleep under the shed, on the horses' bedding, and when the horses gave him a kick Cirino ran to wake up the master crying, 'Uuh!" and then in the morning he currycombed them and groomed them.

Later he had been attracted by the railway which they

were building in the neighbourhood. The coach-drivers and wayfarers had become rarer on the road, and the idiot didn't know what to think, watching the swallows in the air for hours, and blinking his eyelids at the sun to make it out. Then the first time he saw all those people stuffed into the big cars that were leaving the station, he seemed to understand. And after that every day he waited for the train, never a minute wrong in his time, as if he had a clock in his head; and while it fled before him, hurling its noise and smoke in his face, he began to run after it, throwing his arms in the air and howling in a tone of anger and menace, "uuh! uuh!". . .

The host too, whenever he saw the train passing in the distance puffing through the malaria, said nothing, but spat after if all he felt, shaking his head before the deserted sheds and the empty jugs. Formerly affairs had gone so well with him that he had had four wives, so that they called him "Kill-wife," and they said he'd got case-hardened to it, and that he was for taking the fifth, if the daughter of Farmer Turi Oric-chiazza hadn't given him answer: "God preserve us! not if he was made of gold, that Christian there! He eats up his fellow-man like a crocodile!"

But it wasn't true that he'd got case-hardened to it, because when Goodwife Santa had died, his third, he had never taken a mouthful of food till midday, nor drop of water, and he really cried behind the counter of the inn. "This time I want to take one who is used to the malaria," he had said after that event. "I don't want to suffer like this any more."

The malaria killed off his wives, one after the other, but they left him just the same, old and wrinkled, so that it was really hard to imagine that such a man had his own brave homicide on his conscience, intending for all that to take a fourth wife. However, each new time he wanted his wife young and appetizing, for the inn could never prosper without a wife, and for this reason customers had become scarce. Now there was nobody left but Neighbour Mommu, the signalman from the railway just near, a man who never spoke a word, and came to drink his glass between train and

train, sitting himself down on the bench by the door with his shoes in his hand, to rest his legs.

"The malaria doesn't get those lot!" thought Killwife, also never opening his mouth, because if the malaria had made them fall like flies there'd have been nobody to keep that railway going. The poor wretch, since the only man who had poisoned his existence had been removed from his sight, had now only two enemies in the world: the railway which took away his customers, and the malaria which carried off his wives. All the other people on the plain, as far as the eye could reach, had their moments of blessedness, even if they had someone in bed sinking bit by bit, or if the fever was beating them down on the doorstep, with their handkerchiefs on their heads and their cloaks over their shoulders. They took pleasure looking round on the young wheat that was rising prosperous and green as velvet, or the wheat-ears waxing like a sea, and they listened to the long singing of the reapers, stretched out in a line like soldiers, and in every little road the bagpipes were heard, behind which swarms of peasants were just arriving from Calabria for the harvest, dusty people bent under their heavy saddle-sacks, the men in front and the women trailing behind, limping and looking with burnt, tired faces at the road which stretched before them. And on the brink of every ditch, behind every clump of aloes, at the hour when evening drops down like a grey veil, the pipes of the watchmen fluted among the ripe ears of grain, which fell silent, motionless as the wind sank, invaded by the same silence of night.

"There you are!" thought Killwife. "If all that lot of folks can only manage not to leave their bones behind them, and get back home, they'll get back with money in their pockets, they will."

As for him, no! He waited neither for harvest nor anything, and he hadn't the spirit to sing. The evening fell sadly enough, through the empty stables and the dark inn. At that hour the train passed whistling in the distance, and Neighbour Mommu stood beside his signal-box with his flag in his hand; but away up there, when the train had vanished in the shadows, they heard Cirino the simpleton running after it

71

shouting, "Uuh!" and Killwife, in the doorway of the dark, deserted inn, thought to himself that there was no malaria for that lot.

At last, when he could no longer pay the rent for the inn and the stabling, the landlord turned him out after he'd lived there fifty-seven years, and Killwife was reduced to looking for a job on the railway himself, and holding the little flag in his hand when the train passed.

And then, tired with running all day up and down the track, worn out with years and misfortunes, he saw twice a day the long line of carriages crowded with people pass by; the jolly companies of shooters spreading over the plain; sometimes a peasant lad playing the accordion with his head bent, bunched up on the seat of a third-class compartment; the beautiful ladies who looked out of the windows with their heads swathed in a veil; the silver and the tarnished steel of the bags and valises which shone under the polished lamps; the high stuffed seat-backs with their crochet-work covers. Ah, how lovely it must be travelling in there, snatching a wink of sleep! It was as if a piece of the city were sliding past, with the lit-up streets and the glittering shops. Then the train lost itself in the vast mist of the evening, and the poor fellow taking off his shoes for a moment, and sitting on the bench, muttered, "Ah! for that lot there isn't any malaria."

THE ORPHANS

THE ORPHANS

THE LITTLE GIRL appeared in the doorway twisting the corner of her apron between her fingers, and said, "I've come."

Then as nobody took any notice of her, she began to look timidly from one to the other of the village wives who were kneading up the bread, and added: "They told me, 'You go to Neighbour Sidora's."

"Come on, come on," cried Goodwife Sidora, red as a tomato as she turned from the oven-hole. "Wait and I'll make you a nice bread-cake."

"That means they're bringing the extreme unction to Neighbour Nunzia, if they've sent the child away," observed the Licodia goodwife.

One of the women who was helping to knead the bread turned her head round, keeping on working with her fists in the kneading-trough all the time, her arms bare to the elbows, and asked the child:

"How is your step-mother?"

The child didn't know the woman, so she looked at her with wide eyes, and then lowering her head again, and rapidly, nervously twisting the corner of her apron, she mumbled in a low tone:

"She's in bed."

"Don't you hear there's the Host in the house?" replied the Licodia woman. "Now the neighbours have begun to lament round the door."

"When I've got the bread in the oven," said Neighbour Sidora, "I shall run across for a minute myself to see if they're not wanting anything. Master Meno will lose his right arm if this wife dies as well."

"There's some who have no luck with their wives, like others who are always unlucky with their cattle. As many as they get they are bound to lose. Look at Goodwife Angela!"

"Last night," added the Licodia woman, "I saw Neighbour Meno standing on his doorstep, come home from the vineyard before Ave Maria, and he was wiping his nose with his handkerchief."

"Yet you know," added the gossip who was kneading the bread, "he's a blessed good hand at killing off his wives. In less than three years this makes two daughters of Shepherd Nino that he's finished off, one after the other! Wait a bit, and he'll do for the third one, and then he'll get everything that belongs to Shepherd Nino."

"But is this child here Neighbour Nunzia's daughter or is she by the first wife?"

"She's by the first wife. And the second one was as fond of her as if she was her own child, because the little orphan was her neice."

The child, hearing them speaking about her, began to cry quietly in a corner, to ease her aching heart, which she had kept still up till then by fidgeting with her apron.

"Come here then, come here," said Neighbour Sidora again. "The bread-cake is all nice and done. There, don't you cry, your mamma is in Paradise."

Then the child wiped here eyes with her fists, the more readily because Neighbour Sidora was just setting about to open the oven.

"Poor Neighbour Nunzia!" a neighbour woman came saying in the doorway. "The grave-diggers have set off just now. They've just this minute gone past."

"Save us from it! I am a daughter of Holy Mary!" exclaimed the goodwives crossing themselves.

Goodwife Sidora took the bread-cake from the oven, dusted the ashes off it, and gave it fiery hot to the child, who took it in her pinafore and went off with it very quietly,

blowing on it.

"Where are you going?" Goodwife Sidora shouted after her. "You stop here. There's a bogey-man at home, with a black face, and he runs off with folks."

The orphan child listened very seriously, opening wide here eyes. Then she answered with the same obstinate little voice:

"I'm going to take it to mamma."

"Your mother's gone away. You stop here," repeated the neighbour. "You stop here and eat your bread-cake."

Then the child squatted on the doorstep, so unhappy, holding her bread-cake in her hands without thinking about it.

All at once, seeing her father approaching she got up quickly and ran to meet him. Neighbour Meno entered without saying anything, and sat in a corner with his hands hanging between his knees, long-faced, his lips white as paper, not having taken a mouthful of food since yesterday, he was so broken-hearted. He looked round at the women as if to say: I'm in a sad way!

The women, seeing him with his black kerchief round his neck, surrounded him in a circle, their hands still white with flour, sympathizing with him in chorus.

"Don't talk to me, Neighbour Sidora," he repeated, shaking his head and heaving his shoulders. "This is a thorn that'll never come out of my heart! A real saint that woman! I didn't deserve her, if I may say so. Even yesterday, bad as she was, she got up to see to the foal that is just weaned. And she wouldn't let me fetch the doctor so as not to spend money nor buy medicine. I shall never find another wife like her. You mark my word! Leave me alone and let me cry. I've reason to!"

And he kept shaking his head and swelling his shoulders, as if his trouble was heavy on him.

"As for finding another wife," added the Licodia woman to cheer him up, "you've only to look round for one."

"No! no!" Neighbour Meno kept repeating, with his head down like a mule. "I shall never find another wife like her. This time I'll stop a widower. I'm telling you."

Goodwife Sidora lifted up her voice: "Don't you talk rash, it doesn't do! You ought to look round for another wife, if for no other reason but out of regard for this poor little orphan, else who's going to look after her, when you're away in the country! You don't want to leave her in the middle of the road?"

"You find me another wife like her if you can! She didn't wash herself so as not to dirty any water, and she waited on me in the house better than a man-servant, loving and so faithful she wouldn't have robbed me of a handful of beans from the shed, and she never as much as opened her mouth to say, 'You give me this!' And then a fine dowry with it all, stuff worth its weight in gold! And now I've got to give it back, because there are no children! The sexton told me just now he was coming with the holy water. And how fond she was of that little thing there, because she reminded her of her poor sister! Any other woman, who wasn't her aunt, would have just cast the evil eye on her, poor little orphan."

"If you take the third daughter of Shepherd Nino everything will come all right, for the orphan and the dowry," said the Licodia woman.

"That's what I say myself! But don't talk to me, for my mouth is bitter as gall."

"That's not the way to be talking now," seconded Goodwife Sidora. "Better take a mouthful of something to eat, Neighbour Meno, for you're at your last gasp."

"No! no!" Neighbour Meno kept repeating. "Don't talk to me about eating, I've got a knot in my throat."

Neighbour Sidora put before him on a stool the hot bread with black olives, a piece of sheep's cheese, and the flask of wine. And the poor fellow began to munch slowly, slowly, keeping on mumbling with his long face.

"Such bread," he observed, becoming moved to tenderness. "Such bread as she made, the poor departed soul, there wasn't her like for it. It was as soft as meal, it was! And with a handful of wild fennel she'd make you a soup that would make you lick your fingers after it. Now I shall have to buy bread at the shop, from that thief of a Master Puddo, and I shall get no more hot soup, every time I come

home wet through like a new hatched chicken. And I shall have to go to bed on a cold stomach. Even the other night, while I was sitting up with her, after I'd been hoeing all day breaking up the lumps on the slope, and I heard myself snoring, sitting beside the bed, I was so tired, the poor soul said to me: 'Go and eat a spoonful. I've left the soup for you warm by the fire.' And she was always thoughtful for me, at home, mindful of whatever there was to be done, this, that and the other, so that she could never have done talking about it, telling me her last advice, like one who is setting off for a long journey, and I hearing her all the time murmuring when I was half asleep and half awake. And she went happy into the other world, with her crucifix on her breast, and her hands folded over it. She's got no need of rosaries and masses, saint that she is! The money for the priest would be money thrown away."

"It's a world of troubles!" exclaimed the neighbour woman. "And how Goodwife Angela's donkey, just close here, is going to die of indigestion."

"My troubles are worse than that!" wound up Neighbour Meno wiping his mouth with the back of his hand. "No, don't make me eat any more, for every mouthful goes down into my stomach like lead. Better you eat, poor innocent child who doesn't understand anything. Now you'll have nobody to wash you and comb your hair. Now you'll have no mother to keep you under her wing like a mother-hen, and you are lost as I am. I found you that one, but another step-mother like her you'll never have, my child."

The little girl, all moved, pushed out her lips again and put her fists to her eyes.

"No, you can't do no less, I say," repeated Gossip Sidora "You've got to look for another wife, out of regard for this poor little orphan who'd be left on the streets."

"And me, how am I left? And my young foal, and my house, and who's going to see to the fowls? Let me weep, Neighbour Sidora! I'd better have died myself, instead of that poor soul who's gone."

"Be quiet now, you don't know what you're saying, and you don't know what it means, a home without a master!"

"Ay, that's true enough!" agreed Neighbour Meno, somewhat comforted

"Just think of poor Goodwife Angela, if you like! First she's lost her husband, then her big son, and now her donkey is dying as well!"

"If the donkey's got indigestion, he'd better be bled under the girth," said Neighbour Meno.

"You come and look at it, you understand about it," added the goodwife, "You'll be doing a work of charity for the soul of your wife."

Neighbour Meno got up to go to Goodwife Angela's, and the orphan ran after him like a chicken, now she had no one else in the world. Gossip Sidora, good housewife, reminded him:

"And what about the house? How are you leaving it, now there's nobody in it?"

"I've locked the door; and then Cousin Alfia lives just opposite, to keep an eye on it."

The ass of Neighbour Angela was stretched out in the middle of the courtyard, with his nose cold and his ears drooping, struggling from time to time with his four hooves in the air, while the pains contracted his sides like a big pair of bellows. The widow, sitting before him on the stones, with her hands clutching her grey hair, and her eyes dry and despairing, watched him, pale as a dead woman.

Neighbour Meno began to walk round the animal, touching its ears, looking into its eyes, and as he saw that the blood was still flowing from the side, black, drop by drop, collecting at the ends of the bristly hairs, he asked:

"Then they have bled him?"

The widow fixed her gloomy eyes on his face without replying, and nodded her head.

"Then there's nothing more to be done," concluded Neighbour Meno, and he stood there watching the ass stretch himself out on the stones, rigid, with its hair all ruffled like a dead cat.

"It's the will of God, sister!" he said to comfort her. "We are both of us ruined, both of us."

He had seated himself on the stones beside the widow.

with his little girl between his knees, and they were silent all of them watching the poor creature beating the air with its hooves, from time to time, just like a dying man.

When Gossip Sidora had finished taking the bread from the oven she too came into the courtyard, along with Cousin Alfia, who had put on her new dress, and her silk kerchief on her head, to come for a minute's chat, and Gossip Sidora said to Neighbour Meno, drawing him aside: "Shepherd Nino won't be willing to give you the other daughter, seeing that they die like flies with you, and he loses the dowry if he does. And then Santa is too young, and there's the danger that she'd fill your house with children."

"If only they were boys, never mind! But what there is to fear is that they'd be girls. I'm a downright unfortunate man."

"There's always Cousin Alfia. She isn't so young as she was, and she's got her own bit, her house and a piece of vineyard."

Neighbour Meno turned his eyes on Cousin Alfia, who was pretending to look at the ass, with her hands on her hips, and he concluded:

"If that's how it is, we can talk about it after. But I'm a downright unlucky man."

Goodwife Sidora up and said:

"Think of those that are worse off than you, think of them."

"There aren't any, I tell you! I shall never find another wife like her! I shall never be able to forget her, not if I marry ten times more! Neither will this poor little orphan forget her."

"Be quiet, you'll forget her. And the child as well will forget her. Hasn't she forgotten her own true mother? You just look at Neighbour Angela, now her donkey's dying! And she's got nothing else! She, yes, she'll always remember it."

Cousin Alfia saw it was time for her to put in too, with a long face, and she began again the praising of the dead woman. She had arranged her in the coffin with her own hands, and put a handkerchief of fine linen on her face. Because she had plenty of linen and white things, though she

said it herself. Then Neighbour Meno, touched, turned to Neighbour Angela, who never moved, no more than if she was made of stone, and said:

"Well, now what are you waiting for, why don't you have the ass skinned? At least get the money for the hide."

THE PROPERTY

THE TRAVELLER passing along by the Lake of Lentini, stretched out there like a piece of dead sea, and by the burnt-up stubblefields of the Plain of Catania, and the evergreen orange-trees of Francoforte, and the grey cork-trees of Resecone, and the deserted pasture-lands of Passanetto and of Passinatello, if ever he asked, to while away the tedium of the long dusty road, under the sky heavy with heat in the hour when the litter-bells ring sadly in the immense campagna, and the mules let their heads and tails hang helpless, and the litter-driver sings his melancholy song so as not to be overcome by the malaria-sleep, "Whom does the place belong to?" was bound to get for answer, "To Mazzaro." And passing near to a farmstead as big as a village, with store barns that looked like churches, and crowds of hens crouching in the shade of the big well, and the women putting their hands over their eyes to see who was going by:— "And this place?" — "To Mazzaro." — And you went on and on, with the malaria weighing on your eyes, and you were startled by the unexpected barking of a dog, as you passed an endless, endless vineyard, which stretched over hill and plain, motionless, as if the dust upon it were weighing it down, and the watchman stretched out face downwards with his gun beneath him, beside the valley, raised his head sleepily to see who it might be. "To Mazzaro." — Then

came an olive grove thick as a wood, under which the grass never grew, and the olive-gathering went on until March. They were the olive trees belonging to Mazzaro. And towards evening, as the sun sunk red as fire, and the country-side was veiled with sadness, you met the long files of Mazzaro's ploughs coming home softly, wearily from the fallow land, and the oxen slowly crossing the ford, with their muzzles in the dark water; and you saw on the far-off grazing land of Canziria, on the naked slope, the immense whitish blotches of the flocks of Mazzaro; and you heard the shepherd's pipe resounding through the gullies, and the bell of the ram sometimes ringing and sometimes not, and the solitary singing lost in the valley.

All Mazzaro's property. It seemed as if even the setting sun and the whirring cicalas belonged to Mazzaro, and the birds which went on a short, leaping flight to nestle behind the clods, and the crying of the horned-owl in the wood. It was as if Mazzaro had become as big as the world, and you walked upon his belly. Whereas he was an insignificant little fellow, said the litter-driver, and you wouldn't have thought he was worth a farthing, to look at him, with no fat on him except his paunch, and it was a marvel however he filled that in, for he never ate anything more than a penn'orth of bread, for all that he was rich as a pig, but he had a head on his shoulders that was keen as a diamond, that man had.

In fact, with that head as keen as a diamond he had got together all the property, whereas previously he had to work from morning till night, hoeing, pruning, mowing, in the sun and rain and wind, with no shoes to his feet, and not a rag of a cloak to his back; so that everybody remembered the days when they used to give him kicks in the backside, and now they called him *Excellency*, and spoke to him cap in hand. But for all that he hadn't got stuck-up, now that all the Excellencies of the neighbourhood were in debt to him, so that he said *Excellency* meant poor devil and bad payer; he still wore the peasant's stocking-cap, only his was made of black silk, which was his only grandeur, and lately he had started wearing a felt hat, because it cost less than the long silk stocking-cap. He had possessions as far as his eyes could

reach, and he was a long-sighted man — everywhere, right and left, before and behind, in mountain and plain. More than five thousand mouths, without counting the birds of the air and the beasts of the earth, fed upon his lands, without counting his own mouth, that ate less than any of them, and was satisfied with a penn'orth of bread and a bit of cheese, gulped down as fast as he could, standing in a corner of the store-barn big as a church or in the midst of the corn-dust, so that you could hardly see him, while his peasants were emptying the sacks, or on top of a straw-stack, when the wind swept the frozen country, in the time of the sowing of the seed, or with his head inside a basket, in the hot days of harvest-time. He didn't drink wine, and he didn't smoke, he didn't take snuff, although indeed he grew plenty of tobacco in his fields beside the river, broadleaved and tall as a boy, the sort that is sold at ninety shillings. He hadn't the vice of gaming nor of women. As for women he'd never had to bother with any one of them save his mother, who had cost him actually a dollar when he'd had her carried to the cemetery.

And he had thought about it and thought about it times enough, all that property means, when he went with no shoes on his feet, to work on the land that was now his own, and he had proved to himself what it was to earn his shilling a day in the month of July, to work on with your back bent for fourteen hours, with the foreman on horseback behind you, laying about you with a stick if you stood up to straighten yourself for a minute. Therefore he had not let a minute of his whole life pass by that wasn't devoted to the acquiring of property; and now his ploughs were as many as the long strings of crows that arrive in November; and other strings of mules, endless, carried the seed; the women who were kept squatting in the mire, from October to March, picking up his olives, you couldn't count them, as you can't count the magpies that come to steal the olives; and in vintage time whole villages came to his vineyards, so that as far as ever you could hear folks singing, in the countryside, it was at Mazzaro's vintage. And then at harvest time Mazzaro's reapers were like an army of soldiers, so that to

feed all those folks, with biscuit in the morning and bread and bitter oranges at nine o'clock and at mid-day, and home-made macaroni in the evening, it took shoals of money, and they dished up the ribbon-macaroni in kneading-troughs as big as wash-tubs. For that reason, when nowadays he went on horseback along the line of his reapers, his cudgel in his hand, he didn't miss a single one of them with his eye, and kept shouting: "Bend over it, boys!" He had to have his hand in his pocket all the year round, spending, and simply for the land-tax the King took so much from him that Mazzaro went into a fever every time.

However, every year all those store-barns as big as churches were filled up with grain so that you had to raise up the roof to get it all in; and every time Mazzaro sold his wine it took over a day to count the money, all good dollar pieces, for he didn't want any of your dirty paper in payment for his goods, and he went to buy dirty paper only when he had to pay the King, or other people; and at the cattle-fairs the herds belonging to Mazzaro covered all the fairground, and choked up the roads, till it took half a day to let them go past, and the saint in procession with the band had at times to turn down another street, to make way for them.

And all that property he had got together himself, with his own hands and his own head, with not sleeping at nights, with catching ague and malaria, with slaving from dawn till dark, and going round under sun and rain, and wearing out his boots and mules — wearing out everything except himself, thinking of his property, which was all he had in the world, for he had neither children nor grandchildren, nor relations of any sort; he'd got nothing but his property. And when a man is made like that, it just means he is made for property.

And property was made for him. It really seemed as if he had a magnet for it, because property likes to stay with those who know how to keep it, and don't squander it like that baron who had previously been Mazzaro's master, and had taken him out of charity, naked and ignorant, to work on his fields; and the baron had been owner of all these meadows, and all those woods, and all those vineyards, and all those

herds, so that when he came down to visit his estates on horseback, with his keepers behind him, he seemed like a king, and they got ready his lodgings and his dinner for him, the simpletons, so that everybody knew the hour and the minute when he was due to arrive, and naturally they didn't let themselves be caught with their hands in the sack.

"That man absolutely asks to be robbed!" said Mazzaro, and he almost burst himself laughing when the baron kicked his behind, and he rubbed his rear with his hand, muttering: "Fools should stop at home. Property doesn't belong to those that have got it, but to those that know how to acquire it." He, on the contrary, since he had acquired his property, certainly didn't send to say whether he was coming to superintend the harvest, or the vintage, and when and in what way, but he turned up unexpectedly on foot or on mule-back, without keepers, with a piece of bread in his pocket, and he slept beside his own sheaves, with his eyes open and the gun between his legs.

And in that way Mazzaro little by little became master of all the baron's possessions; and the latter was turned out, first from the olive groves, then from the vineyards, then from the grazing land, and then from the farmsteads and finally from his very mansion, so that not a day passed but he was signing stamped paper, and Mazzaro put his own brave cross underneath. Nothing was left to the baron but the stone shield that used to stand over his entrance-door — which was the only thing he hadn't wanted to sell, saying to Mazzaro: "There's only this, out of everything I've got, which is no use for you." And that was true; Mazzaro had no use for it, and wouldn't have given two cents for it. The baron still said *thou* to him, but he didn't kick his behind any longer.

"Ah what a fine thing, to have Mazzaro's fortune!" folks said, but they didn't know what it had taken to make that fortune, how much thinking, how much struggling, how many lies, how much danger of being sent to the galleys, and how that head was sharp as a diamond had worked day and night, better than a millwheel, to get all that property together. If the proprietor of a piece of farm-land adjoining

his persisted in not giving it up to him, and wanted to take Mazzaro by the throat, he had to find some stratagem to force him to sell, to make him fall, in spite of the peasant's shrewdess. He went to him, for example, boasting about the fertility of a holding which wouldn't even produce lupins, and kept on till he made him believe it was the promised land, till the poor devil let himself be persuaded into leasing it, to speculate with it, and then he lost the lease, his house, and his own bit of land, which Mazzaro got hold of — for a bit of bread. And how many annoyances Mazzaro had to put up with! His half-profits peasants coming to complain of the bad seasons, his debtors always sending their wives in a procession to tear their hair and beat their breasts trying to persuade him not to turn them out and put them in the street, by seizing their mule or their donkey, so that they'd not have anything to eat.

"You see what I eat," he replied. "Bread and onion! and I've got all those store-barns cram full, and I'm owner of all that stuff." And if they asked him for a handful of beans from all that stuff, he said:

"What, do you think I stole them? Don't you know what it costs, to sow them, and hoe them, and harvest them?" And if they asked him for a cent he said he hadn't got one, which was true, he hadn't got one. He never had half-a-dollar in his pocket; it took all his money to make that property yield and increase, and money came and went like a river through the house. Besides money didn't matter to him; he said it wasn't property, and as soon as he'd got together a certain sum he immediately bought a piece of land; because he wanted to get so that he had as much land as the king, and be better than the king, because the king can neither sell his land nor say it is his own.

Only one thing grieved him, and that was that he was beginning to get old, and he had to leave the earth there behind him. This was an injustice on God's part, that after having slaved one's life away getting property together, when you've got it, and you'd like some more, you have to leave it behind you. And he remained for hours sitting on a small basket, with his chin in his hands, looking at his

vineyards growing green beneath his eyes, and his fields of ripe wheat waving like a sea, and the olive groves veiling the mountains like a mist, and if a half-naked boy passed in front of him, bent under his load like a tired ass, he threw his stick at his legs, out of envy, and muttered: "Look at him with his length of days in front of him; him who's got nothing to bless himself with!"

So that when they told him it was time for him to be turning away from his property, and thinking of his soul, he rushed out into the court-yard like a madman, staggering, and went round killing his own ducks and turkeys, hitting them with his stick and screaming: "You're my own property, you come along with me!"

THE STORY OF
SAINT JOSEPH'S ASS

THEY had bought him at the fair at Buccheri when he was quite a foal, when as soon as he saw a she-ass he went up to her to find her teats; for which he got a good many bangs on the head and showers of blows upon the buttocks and caused a great shouting of "Gee back!" Neighbour Neli, seeing him lively and stubborn as he was, a young creature that licked his nose after it had been hit, giving his ears a shake, said, "This is the chap for me!" And he went straight to the owner, holding his pocket in his hand which clasped the eight dollars.

"It's a fine foal," said the owner, "and it's worth more than eight dollars. Never mind if he's got that black and white skin, like a magpie. I'll just show you his mother, whom we keep there in the bough-shelter because the foal has always got his nose at the teats. You'll see a fine black beast there; she works for me better than a mule, and has brought me more young ones than she has hairs on her back. Upon my soul, I don't know where that magpie jacket has come from, on the foal. But he's sound in the bone, I tell you! And you don't value men according to their faces. Look what a chest, and legs like pillars! Look how he holds his ears! An ass that keeps his ears straight up like that, you can put him in a cart or in the plough as you like, and make him carry ten quarters of buckwheat better than a mule, as true as this holy day today! Feel this tail, if you and all your family couldn't hang on to it!"

Neighbour Neli knew it better than he; but he wasn't such a fool as to agree, and stood on his own, with his hand in his pocket, shrugging his shoulders and curling his nose, while the owner led the colt round in front of him.

"Hm!" muttered Neighbour Neli, "with that hide on him, he's like Saint Joseph's ass. Those coloured animals are all Jonahs, and when you ride through the village on their backs everybody laughs at you. What do you want me to make you a present of, for Saint Joseph's ass?"

Then the owner turned his back on him in a rage, shouting that if he didn't know anything about animals, or if he hadn't got the money to pay with, he'd better not come to the fair and make Christians waste their time, on the blessed day that it was.

Neighbour Neli let him swear, and went off with his brother, who was pulling him by his jacket-sleeve, and saying that if he was going to throw away his money on that ugly beast, he deserved to be kicked.

However, on the sly they kept their eye on the Saint Joseph's ass, and on its owner who was pretending to shell some broad-beans, with the halter-rope between his legs, while Neighbour Neli went wandering round among the groups of mules and horses, and stopping to look, and bargaining for first one and then the other of the best beasts, without ever opening the fist which he kept in his pocket with the eight dollars, as if he'd got the money to buy half the fair. But his brother said in his ear, motioning towards the ass of Saint Joseph: "That's the chap for us!"

The wife of the owner of the ass from time to time ran to look what had happened, and finding her husband with the halter in his hand, she said to him: "Isn't the Madonna going to send us anybody today to buy the foal?"

And her husband answered every time: "Not so far! There came one man to try for him, and he liked him. But he drew back when he had to pay for him, and has gone off with his money. See him, that one there, in the white stocking-cap, behind the flock of sheep. But he's not bought anything up to now, which means he'll come back."

The woman would have liked to sit down on a couple of

stones, just close to her ass, to see if he would be sold. But her husband said to her:

"You clear out! If they see we're waiting, they'll never come to bargain."

Meanwhile the foal kept nuzzling with his nose between the legs of the she-asses that passed by, chiefly because he was hungry, and his master, the moment the young thing opened his mouth to bray, fetched him a bang and made him be quiet, because the buyers wouldn't want him if they heard him.

"It's still there," said Neighbour Neli in his brother's ear, pretending to come past again to look for a man who was selling broiled chickpeas. "If we wait till ave maria we can get him for a dollar less than the price we offered."

The sun of May was hot, so that from time to time, in the midst of the shouting and swarming of the fair there fell a great silence over all the fair-ground, as if there was nobody there, and then the mistress of the ass came back to say to her husband:

"Don't you hold out for a dollar more or less, because there's no money to buy anything in with, this evening; and then you know the foal will eat a dollar's worth in a month, if he's left on our hands."

"If you're not going," replied her husband, "I'll fetch you a kick you won't forget!"

So the hours of the fair rolled by, but none of those who passed before the ass of Saint Joseph stopped to look at him; for sure enough his master had chosen the most humble position, next to the low-price cattle, so as not to make him show up too badly beside the beautiful bay mules and the glossy horses! It took a fellow like Neighbour Neli to go and bargain for Saint Joseph's ass, which set everybody in the fair laughing the moment they saw it. With having waited so long in the sun the foal let his head and his ears drop, and his owner had seated himself gloomily on the stones, with his hands also dangling between his knees, and the halter in his hands, watching here and there the long shadows, which began to form in the plain as the sun went down, from the legs of all such beast which had not found a buyer. Then

Neighbour Neli and his brother, and another friend whom they had picked up for the occasion, came walking that way, looking into the air, so that the owner of the ass also twisted his head away to show he wasn't sitting there waiting for them; and the friend of Neighbour Neli said like this, looking vacant, as if the idea had just come to him:

"Oh, look at the ass of Saint Joseph! Why don't you buy him, Neighbour Neli?"

"I asked the price of him this morning; he's too dear. Then I should have everybody laughing at me with that black-and-white donkey. You can see that nobody would have him, so far."

"That's a fact, but the colour doesn't matter, if a thing is any use to you."

And he asked of the owner:

"How much do you expect us to make you a present of, for that Saint Joseph's donkey?"

The wife of the owner of the ass of Saint Joseph, seeing that the bargaining had started again, came edging softly up to them, with her hands clasped under her short cloak.

"Don't mention such a thing!" Neighbour Neli began to shout, running away across the plain. "Don't mention such a thing to me; I won't hear a word of it."

"If he doesn't want it, let him go without it," answered the owner. "If he doesn't take it, somebody else will. It's a sad man who has nothing left to sell, after the fair!"

"But I mean him to listen to me, by the blessed devil I do!" squealed the friend. "Can't I say my own fool's say like anybody else?"

And he ran to seize Neighbour Neli by the jacket; then he came back to speak a word in the ear of the ass' owner, who now wanted at any cost to go home with his little donkey, so the friend threw his arms round his neck, whispering: "Listen! a dollar more or less, — if you don't sell it today, you won't find another softy like my pal here to buy your beast, which isn't worth a cigar."

And he embraced the ass' mistress also, talking in her ear, to get her on his side. But she shrugged her shoulders and replied with a sullen face:

"It's my man's business. It's nothing to do with me. But if he lets you have it for less than nine dollars he's a simpleton, in all conscience! It cost us more!"

"I was a lunatic to offer eight dollars this morning," put in Neighbour Neli. "You see now whether you've found anybody else to buy it at that price. There's nothing left in all the fair but three or four scabby sheep and the ass of Saint Joseph. Seven dollars now, if you like."

"Take it," suggested the ass' mistress to her husband, with tears in her eyes. "We haven't a cent to buy anything in to-night, and Turiddu has got the fever on him again; he needs some sulphate."

"All the devils!" bawled her husband. "If you don't get out, I'll give you a taste of the halter!" "Seven and a half, there!" cried the friend at last, shaking him hard by the jacket collar. "Neither you nor me! This time you've got to take my word, by all the saints in paradise! And I don't ask as much as a glass of wine. You can see the sun's gone down. Then what are you waiting for, the pair of you?"

And he snatched the halter from the owner's hand, while Neighbour Neli, swearing, drew out of his pocket the fist with the eight dollars, and gave them him without looking at them, as if he was tearing out his own liver. The friend drew aside with the mistress of the ass, to count the money on a stone, while the owner of the ass rushed through the fair like a young colt, swearing and punching himself on the head.

But then he permitted himself to go back to his wife, who was very slowly and carefully counting over again the money in the handkerchief, and he asked:

"Is it right?"

"Yes, it's quite right; Saint Gaetano be praised! Now I'll go to the druggist."

"I've fooled them! I'd have given it to him for five dollars if I'd had to; those coloured donkeys are all Jonahs."

And Neighbour Neli, leading the little donkey behind him down the slope, said:

"As true as God's above I've stolen his foal from him! The colour doesn't matter. Look what legs, like pillars, neighbour. He's worth nine dollars with your eyes shut."

"If it hadn't been for me," replied the friend, "you wouldn't have done a thing. Here, I've still got half a dollar of yours. So if you like, we'll go and drink your donkey's health with it."

And now the colt stood in need of all his health to earn back the seven and a half dollars he had cost, and the straw he ate. Meanwhile he took upon himself to keep gamboling behind Neighbour Neli, trying to bite his jacket in fun, as if he knew it was the jacket of his new master, and he didn't care a rap about leaving for ever the stable where he had lived in the warmth, near his mother, rubbing his muzzle on the edge of the manger, or butting and capering with the ram, or going to rouse up the pig in its corner. And his mistress, who was once more counting the money in the handkerchief in front of the druggist's counter, she didn't either once think of how she had seen the foal born, all black and white with his skin as glossy as silk, and he couldn't stand on his legs yet, but lay nestling in the sun in the yard, and all the grass which he had eaten to get so big and stout had passed through her hands. The only one who remembered her foal was the she-ass, who stretched out her neck braying towards the stable door; but when she no longer had her teats swollen with milk, she too forgot about the foal.

"Now this creature," said Neighbour Neli, "you'll see he'll carry me ten quarters of buckwheat better than a mule. And at harvest I'll set him threshing."

At the threshing the colt, tied in a string with the other beasts, old mules and broken-down horses, trotted round over the sheaves from morning till night, till he was so tired he didn't even want to open his mouth to bite at the heap of straw when they had put him to rest in the shade, now that a little wind had sprung up, so that the peasants could toss up the grain into the air with broad wooden forks, to winnow it, crying, "*Viva Maria!*"

Then he let his muzzle and his ears hang down, like a grown-up ass, his eye spent, as if he was tired of looking out over the vast white campagna which fumed here and there with the dust from the threshing-floors, and it seemed as if

he was made for nothing else but to be let die of thirst and made to trot around on the sheaves. At evening he went back to the village with full saddlebags, and the master's lad went behind him pricking him between the legs, along the hedges of the by-way that seemed alive with the twittering of the tits and the scent of cat-mint and of rosemary, and the donkey would have liked to snatch a mouthful, if they hadn't made him trot all the time, till the blood ran down his legs, and they had to take him to the vet.; but his master didn't care, because the harvest had been a good one, and the colt had earned his seven and a half dollars. His master said: "Now he's done his work, and if I sell him for five dollars, I've still made money by him."

The only one who was fond of the foal was the lad who made him trot along the little road, when they were coming home from the threshing-floor, and he cried while the farrier was burning the creature's legs with a red-hot iron, so that the the colt twisted himself up, with his tail in the air and his ears as erect as when he had roved round the fairground, and he tried to get free from the twisted rope which pressed his lips, and he rolled his eyes with pain almost as if he had human understanding, when the farrier's lad came to change the red hot irons, and his skin smoked and frizzled like fish in a frying-pan. But Neighbour Neli shouted at his son: "Silly fool! What are you crying for? He's done his work now, and seeing that the harvest has gone well we'll sell him and buy a mule, which will be better for us."

Some things children don't understand; and after they had sold the colt to Farmer Cirino from Licodia, Neighbour Neli's son used to go to visit it in the stable to stroke its nose and its neck, and the ass would turn to snuff at him as if its heart were still bound to him, whereas donkeys are made to be tied up where their master wishes, and they change their fate as they change their stable. Farmer Cirino from Licodia had bought the Saint Joseph's ass cheap, because it still had the wound in the pastern; and the wife of Neighbour Neli, when she saw the ass going by with its new master, said: "There goes our luck; that black and white hide brings a jolly threshing floor; and now times go from bad to worse, so that we've

101

even sold the mule again."

Farmer Cirino had yoked the ass to the plough, with the old horse that went like a jewel, drawing out his own brave furrow all day long, for miles and miles, from the time when the larks began to trill in the dawn-white sky, till when the robins ran to huddle behind the bare twigs that quivered in the cold, with their short flight and their melancholy chirping in the mist which rose like a sea. Only, seeing that the ass was smaller than the horse, they had put him a pad of straw on the saddle, under the yoke, and he went at it harder than ever, breaking the frozen sod, pulling with all his might from the shoulder. "This creature saves my horse for me, because he's getting old," said Farmer Cirino. "He's got a heart as big as the plain of Catania, has that ass of St. Joseph! And you'd never think it."

And he said to his wife, who was following behind him clutched in her scanty cloak, parsimoniously scattering the seed:

"If anything should happen to him, think what a loss it would be! We should be ruined, with all the season's work in hand."

And the woman looked at the work in hand, at the little stony desolate field, where the earth was white and cracked, because there had been no rain for so long, the water coming all in mist, the mist that rots the seed; so that when the time came to hoe the young corn it was like the devil's beard, so sparse and yellow, as if you'd burnt it with matches. "In spite of the way we worked that land!" whined Farmer Cirino, tearing off his jacket. "That donkey put his guts into it like a mule! He's the ass of misfortune, he is."

His wife had a lump in her throat when she looked at that burnt-up corn-field, and only answered with the big tears that came to her eyes:

"It isn't the donkey's fault. He brought a good year to Neighbour Neli. It's us who are unlucky."

So the ass of Saint Joseph changed masters once more, for Farmer Cirino went back again with his sickle from the corn-field, there was no need to reap it that year, in spite of the fact that they'd hung images of the saints on to the cane

hedge, and had spenty twenty cents having it blessed by the priest. "The devil is after us!" Farmer Cirino went swearing through those ears of corn that stood up straight like feathers, which even the ass wouldn't eat; and he spat into the air at the blue sky that had not a drop of water in it. Then Neighbour Luciano the carter, meeting Farmer Cirino leading home the ass with empty saddle-bags, asked him: "What do you want me to give you for Saint Joseph's ass?"

"Give me what you like. Curse him and whoever made him," replied Farmer Cirino. "Now we haven't got bread to eat, nor barley to give to the beast."

"I'll give you three dollars because you're ruined; but the ass isn't worth it, he won't last above six months. See what a poor sight he is!"

"You ought to have asked more," Farmer Cirino's wife began to grumble after the bargain was concluded. "Neighbour Luciano's mule has died, and he hasn't any money to buy another. If he hadn't bought the Saint Joseph's ass he wouldn't know what to do with his cart and harness; and you'll see that donkey will bring him riches."

The ass then learnt to pull the cart, which was too high on the shafts for him, and weighed so heavily on his shoulders that he wouldn't have lasted even six months, scrambling his way up the steep rough roads, when it took all Neighbour Luciano's cudgelling to put a bit of breath into his body; and when he went down-hill it was worse, because all the load came down on top of him, and pressed on him so much that he had to hold on with his back curved up in an arch, with those poor legs that had been burnt by fire, so that people seeing him began to laugh, and when he fell down it took all the angels of paradise to get him up again. But Neighbour Luciano knew that he pulled his ton and a half of stuff better than a mule, and he got paid forty cents a half-ton. "Every day the Saint Joseph's ass lives it means a dollar and a dime earned," he said, "and he costs me less to feed than a mule." Sometimes people toiling up on foot at a snail's pace behind the cart, seeing that poor beast digging his hoofs in with no strength left, and arching his spine, breathing quick, his eye hopeless, suggested: "Put a stone under the wheel, and let

that poor beast get his wind." But Neighbour Luciano replied: "If I let him go his own pace he'll never earn me my dollar and a dime a day. I've got to mend my own skin with his. When he can't do another stroke I'll sell him to the lime man, for the creature is a good one and will do for him; and it's not true a bit that Saint Jospeh's asses are Jonahs. I got him for a crust of bread from Farmer Cirino, now he's come down and is poor."

Then the St. Joseph's ass fell into the hands of the lime man, who had about twenty donkeys, all thin skeletons just ready to drop, but which managed nevertheless to carry him his little sacks of lime, and lived on mouthfuls of weeds which they could snatch from the roadside as they went. The lime man didn't want him because he was all covered with scars worse than the other beasts, and his legs seared with fire, and his shoulders worn out with the collar, and his withers gnawed by the plough-saddle, and his knees broken by his falls, and then that black and white skin which in his opinion didn't go at all with his other black animals. "That doesn't matter," replied Neighbour Luciano, "it'll help you to know your own asses at a distance." And he took off another fifteen cents from the dollar and a half which he had asked, to close the bargain. But even the mistress, who had seen him born, would no longer have recognized the Saint Joseph's ass, he was so changed, as he went with his nose to the ground and his ears like an umbrella, under the little sacks of lime, twisting his behind at the blows from the boy who was driving the herd. But the mistress herself had also changed by then, with the bad times there had been, and the hunger she had felt, and the fevers that they'd all caught down on the plain, she, her husband and her Turiddu, without any money to buy sulphate, for one hasn't got a Saint Joseph's ass to sell every day, not even for seven dollars.

In winter, when work was scarcer, and the wood for burning the lime was rarer and further to fetch, and the frozen little roads hadn't a leaf on their hedges, or a mouthful of stubble along the frozen ditchside, life was harder for those poor beasts; and the owner knew that the winter would carry off half of them for him; so that he usually had to buy a good

stock of them in spring. At night the herd lay in the open, near the kiln, and the beasts did the best for themselves pressing close up to one another. But those stars that shone like swords penetrated them in their vulnerable parts, and in spite of their thick hides, and all their sores and galls burned again and trembled in the cold as if they could speak.

However, there are plenty of Christians who are no better off, and even haven't got that rag of a cloak in which the herd-boy curled himself up to sleep in front of the furnace. A poor widow lived close by — in a hovel even more dilapidated than the lime kiln, so that the stars penetrated through the roof like swords, as if you were in the open, and the wind made the few rags of coverlets flutter. She used to do washing, but it was a lean business, because folk washed their own rags, when they were washed at all, and now that her boy was grown she lived by going down to the village to sell wood. But nobody had known her husband, and nobody knew where she got the wood she sold; though her boy knew, because he went to glean it here and there, at the risk of being shot at by the estate-keepers. "If you had a donkey," said the lime-man, who wanted to sell the Saint Joseph's ass because it was no longer any good to him, "you could carry bigger bundles to the village, now that your boy is grown."

The poor woman had a dime or two tied in a corner of a handkerchief, and she let the lime man get them out of her, because it is as they say: "old stuff goes to die in the house of the crazy."

At least the poor Saint Joseph's ass lived his last days a little better, because the widow cherished him like a treasure, thanks to the dimes he had cost her, and she went out at nights to get him straw and hay, and kept him in the hut beside the bed, so that he helped to keep them all warm, like a little fire, he did, in this world where one hand washes the other. The woman, driving before her the ass laden with wood like a mountain, so that you couldn't see his ears, went building castles in the air; and the boy foraged round the hedges and ventured into the margins of the wood to get the load together, till both mother and son imagined themselves growing rich at the trade; till at last the baron's estate-keeper

caught the boy in the act of stealing boughs and tanned his hide for him thoroughly with a stick. To cure the boy the doctor swallowed up all the cents in the handkerchief, the stock of wood, and all there was to sell, which wasn't much; so that one night when the boy was raving with fever, his inflamed face turned towards the wall, and there wasn't a mouthful of bread in the house, the mother went out raving and talking to herself as if she had got the fever as well; and she went and broke down an almond tree close by, though it didn't seem possible that she could have managed to do it, and at dawn she loaded it on the ass to go and sell it. But under the weight, as he tried to get up the steep path, the donkey kneeled down really like Saint Joseph's ass before the Infant Jesus, and couldn't get up again.

"Holy Spirits!" murmured the woman. "Oh carry that load of wood for me, you yourselves."

And some passers-by pulled the ass by the rope and hit his ears to make him get up.

"Don't you see he's dying," said a carter at last, and so the others left him in peace, since the ass had eyes like a dead fish, and a cold nose, and shivers running over his skin.

The woman thought of her son in his delirium, with his face red with fever, and she stammered:

"Now what shall we do? Now what shall we do?"

"If you want to sell him with all the wood I'll give you forty cents for him," said the carter, who had his wagon empty. And as the woman looked at him with vacant eyes, he added, "I'm only buying the wood, because *that's* all the ass is worth!" And he gave a kick at the carcass, which sounded like a burst drum.

BLACK BREAD

NEIGHBOUR NANNI had hardly taken his last breath, and the priest in his stole was still there, when the quarrel broke out between the children as to who should pay the costs of the burial, and they went at it till the priest with the aspersorium under his arm was driven away.

For Neighbour Nanni's illness had been a long one, the sort that eats away the flesh off your bones and the things out of your house. Every time the doctor spread his piece of paper on his knee to write out the prescription, Neighbour Nanni watched his hands with beseeching eyes, and mumbled, "Write it short, you honour; anyhow write it short, for mercy's sake."

The doctor carried out his own job. Everybody in the world carries out his own job. In carrying out his, Farmer Nanni had caught that fever down there at Lamia, land blessed by God, producing corn as high as a man. In vain the neighbours said to him, "Neighbour Nanni, you'll leave your bones on that half-profits farm!"

"As if I was a baron," he replied, "to do what I like and choose!"

The brothers, who were like the fingers on the same hand as long as their father lived, had now each one to think for himself. Santo had a wife and children on his back; Lucia was left without any dowry, as good as turned on the street; and Carmenio, if he wanted to have bread to eat, would have to go away from home and find himself a master. Then the

mother, who was old and ailing, didn't know whose business it was to keep her, for none of the three children had anything at all.

The oxen, the sheep, the store in the granary had all gone with their owner. There remained the dark house, with the empty bed, and the equally dark faces of the orphans. Santo carried his things across, with Red-head, his wife, and said he'd take his mamma to live with him. "Then he won't have to pay house-rent," said the others. Carmenio made up his own bundle and went as shepherd to Herdsman Vito, who had a piece of grazing land at Camemi; and Lucia threatened to go into service rather than live with her sister-in-law.

"No!" said Santo. "It shan't be said that my sister had to be servant to other folks."

"He wants me to be servant to Red-head," grumbled Lucia.

The great question was this sister-in-law who had driven herself into the family like a nail. "What is there to be done, now I've got her?" sighed Santo shrugging his shoulders. "I should have listened in time to that good soul, my father."

That good soul had preached to him: "Leave yon Nena alone, for she's got never a bit of dowry, nor house, nor land."

But Nena was always at his side, at the Castelluccio farm; whether he was hoeing or mowing, she was there gathering the corn into sheaves, or removing the stones from under his feet with her hands; and when they rested, at the door of the great farm-place, they sat together with their backs to the wall, at the hour when the sun was dying over the fields, and everything was going still.

"Neighbour Santo, if God is good you won't have lost your labours this year."

"Neighbour Santo, if the harvest turns out well, you ought to take the big field, down on the plain; because the sheep have been on it, and it's rested for two years."

"Neighbour Santo, this winter, if I've time, I want to make you a pair of thick leggings to keep you warm."

Santo had got to know Nena while he was working at Castelluccio, a girl with red hair, daughter of the keeper,

whom nobody wanted. So for that reason, poor thing, she made a fuss of every dog that passed, and she denied herself the bread from her mouth in order to make neighbour Santo a present of a black silk stocking-cap, every year at Saint Agrippina's day, and to have a flask of wine for him, or a piece of cheese, when he arrived at Castelluccio. "Take this, for my sake, Neighbour Santo. It's the same as the master drinks." Or else: "I've been thinking, you never had a bit of something to eat with your bread not all last week."

He didn't say no, but took everything. The most he ever did was to say out of politeness: "This won't do, Neighbour Nena, you deny your own self to give to me."

"I like it better for you to have it."

And then, every Saturday night when Santo went home, that dear departed soul used to tell him again: Leave yon Nena alone, for she hasn't got this; leave yon Nena alone, for she hasn't got the other.

"I know I've got nothing," said Nena as she sat on the low wall facing the setting sun. "I've neither land nor houses; and to get together that bit of linen I've had to go without bread to eat. My father is a poor keeper, who lives at his master's charge, and nobody wants to saddle himself with a wife without a dowry."

Nevertheless the nape of her neck was fair, as it usually is with red-haired people; and as she sat with her head bowed, all those thoughts heavy inside it, the sun glowed among the golden-coloured hairs behind her ears, and lit on her cheeks that had a fine down like a peach; and Santo looked at her flax-blue eyes, and at her breast which filled her stays and swayed like the corn-field.

"Don't you worry, Neighbour Nena," he said. "You won't go short of husbands."

She shook her head, saying no; and her red earrings that were almost like coral caressed her cheeks. "No, no, Neighbour Santo. I know I'm not beautiful, and nobody wants me."

"Look though!" said he all at once, as the idea came to him. "Look how opinions vary! They say red hair is ugly, and yet on you now it doesn't strike me as bad."

The good departed soul, his father, when he saw that Santo was altogether smitten with Nena and wanted to marry her, had said to him one Sunday: "You want her whether-or-not, that Red-head? Say the truth, you want her whether or not?"

Santo, with his back to the wall and his hands behind him, didn't dare to raise his head; but he nodded yes, yes, that he didn't know what to do with himself without the Red-head, and it was the will of God it should be so.

"And have you given it a thought as to how you're going to keep a wife? You know I can give you nothing. But I've one thing to tell you, and your mother here will say the same: think it over before you go and get married, for bread is scarce, and children come quick."

His mother, crouching on the stool, pulled him by the jacket and said to him *sotto voce,* with a long face: "Try and fall in love with the widow of Farmer Mariano, she's rich, and she won't ask a great deal of you, being part paralysed."

"Oh yes!" grumbled Santo, "You may bet Farmer Mariano's widow would take up with a beggar like me!"

Neighbour Nanni also agreed that Farmer Mariano's widow was looking for a husband as rich as herself, hip-lame though she was. And then there'd have been that other misery to look forward to, seeing your grandchildren born lame as well.

"Well, it's for you to think about it," he repeated to his son. "Remember that bread is scarce, and children come quick."

Then towards evening on St. Bridget's day Santo had met the Red-head by chance, as she was gathering wild asparagus beside the path, and she blushed at seeing him as if she didn't know quite well that he had to pass that way going back to the village, and she dropped down the hem of her skirt that she had turned up round her waist for going on all fours among the cactus plants. The young man looked at her, he also went red in the face, and could say nothing. At last he began to stammer that the week was over and he was going home. "You've no messages to send to the village, Neighbour Nena? Tell me if I can do anything."

"If I'm going to sell the asparagus, I'll come along with you, and we'll go the same way," said Red-head. And he, as if stupefied, nodded yes, yes; she added, with her chin on her heaving bosom: "But you don't want me, women are a nuisance to you."

"I'd like to carry you in my arms, Neighbour Nena, carry you in my arms."

Then Neighbour Nena began to chew the corner of the red handkerchief she wore round her head. And Neighbour Santo again had nothing to say; but he looked at her, and looked at her, and changed his saddlebag from one shoulder to the other, as if he couldn't find words to begin. The mint and the marjoram were making the air merry, and the side of the mountain, above the cactuses, was all red with sunset. "You go now," Nena said to him. "You go now, it's late." Then she stood listening to the night crickets rattling away. But Santo didn't move. "You go now, somebody might see us here by ourselves."

Neighbour Santo, who was really going at last, came out again with his old assertion, and another shake of the shoulder to settle his double sack, that he'd have carried her in his arms, he would, he'd have carried her if they'd been going the same road. And he looked Neighbour Nena in the eyes, and she avoided his looks and kept on seeking for the wild asparagus among the stones, and he watched her face that was as red as if the sunset were beating upon it.

"No, Neighbour Santo, you go on by yourself, you know I'm a poor girl with no dowry."

"Let us do as Providence wishes, let us —."

She kept on saying no, that she was not for him, and now her face was dark and frowning. Then neighbour Santo, downcast, settled his bag on his shoulder and moved away, with bent head. But Red-head wanted at least to give him the asparagus that she had gathered for him. They'd make a nice little dish for him, if he would eat them for her sake. And she held out to him the two corners of the full apron. Santo put his arm round her waist and kissed her on the cheek, his heart melting inside him.

At that moment her father appeared, and the girl ran away

in a fright. The keeper had his gun on his arm, and didn't see at all what should prevent him from laying neighbour Santo out for practising this treachery on him.

"No! I'm not like that!" replied Santo with his hands crossed on his breast. "I want to marry your daughter, I do. Not for fear of the gun; but I'm the son of a good man, and Providence will help us because we do no wrong."

So the wedding took place on a Sunday, with the bride in her holiday dress, and her father the keeper in new boots in which he waddled like a tame duck. Wine and baked beans made even Neighbour Nanni merry, though he had the malaria on him bad; and the mother took out of the chest a pound or two of worsted yarn which she had put aside toward a dowry for Lucia, who was already eighteen, and who combed and arranged her hair for half an hour every Sunday morning before going to mass, looking at herself in the water of the wash-bowl, for a mirror.

Santo, with the tips of his ten fingers stuck in the pockets of his coat, exulted as he looked at the red hair of his bride, at the yarn, and all the celebration which there was for him that Sunday. The keeper, with a red nose, hobbled inside his shoes and wanted to kiss them all around, one after the other.

"Not me!" said Lucia, sulky because of the yarn they were taking from her. "This isn't water for my mouth."

She stayed in a corner pulling a sulky face, as if she already knew what her lot would be the moment her parents were gone.

And now sure enough she had to cook the bread and sweep the house for her sister-in-law, who as soon as God sent daylight set off for the field with her husband, although she was again with child, she being worse than a cat for filling the house with little ones. There was more needed now than presents at Christmas and at St. Agrippina's day, or than the pretty talk she used to have with Neighbour Santo at Casteluccio. That swindler of a keeper had done well for himself marrying off his daughter without a dowry, and now Neighbour Santo had to see about maintaining her. Since he'd got Nena he saw that there wasn't bread enough for the

two of them, and that they'd got to wring it out of the earth at Licciardo, in the sweat of their brow.

As they went to Licciardo with the double bag over their shoulder, wiping the sweat from their foreheads on their shirt-sleeves, they had the young corn always in their mind and in front of their eyes, they saw nothing else but that between the stones of the path. It was to them like the thought of one who is sick and whom you have always heavy on your heart, that corn; first yellow, swamped in mud with all the rain; and then, when it did begin to get a bit of hold, came the weeds, so that Nena had made pitiful work of both her hands, pulling them out one by one, bending down over all that load of her belly, drawing her skirt above her knees so as not to hurt the corn. And she didn't feel the weight of her child, nor the pains of her back, as if every green blade which she freed from the weeds was a child she had borne. And when at last she squatted on the little bank, panting, pushing her hair behind her ears with both her hands, she seemed to see before her the tall ears of June, bending over one above the other as the breeze touched them; and they would reckon up, she and her husband, as he was untying his soaking gaiters, and cleaning his hoe on the grass of the bank: So much seed they had taken, and therefore they'd have so much corn if the ear came to twelvefold or to tenfold or even to sevenfold; the stalk wasn't very stout but the growth was thick. If only March was not too dry, and if only it didn't rain except when rain was needed! Blessed Saint Agrippina must remember them! The sky was clear and the sun lingered in gold on the green meadows, from the firey west, whence the larks fell singing on to the clods, like black dots. Spring was really beginning everywhere, in the cactus hedges, in the bushes of the little road, between the stones, on the roofs of the hamlets green with hope; and Santo, walking heavily behind his companion, who was bent beneath the sack of straw for the animals, with all that belly on her, felt his heart swell with tenderness for the poor thing, and went along talking to her, his voice broken by the steep climbs, about what he'd do if the Lord blessed the corn up to the last. Now they didn't have to talk any more about red

hair, whether it was beautiful or ugly, or any such nonsense. And when treacherous May came with its mists to rob them of all their labours and their hopes of harvest, the husband and wife, seated once more on the bank watching the field going yellow under their eyes, like a sick man departing to the other world, said not a word, their elbows on their knees and their eyes stony in their pale faces.

"This is God's punishment!" muttered Santo. "That sainted soul my father told me how it would be."

And into the hovel of the poor penetrated the ill-humour of the black, muddy little road outside. Husband and wife turned their backs on one another stupefied, and they quarrelled every time Red-head asked for money to buy necessaries, or whenever the husband came home late, or when there wasn't enough wood for the winter, or when the wife became slow and idle with her child-bearing; long faces, ugly words, and even blows. Santo seized Nena by her red hair, and she set her nails in his face; the neighbours came running up, and Red-head squealed that that villain wanted to make her have a miscarriage, and that he didn't care if he sent a soul to hell. Then, when Nena had her baby, they made peace again, and Neighbour Santo went carrying the infant girl in his arms, as if he had fathered a princess, and ran to show her to his relations and his friends, he was so pleased. And for his wife, as long as she was in bed he made her broth, he swept the house, he cleaned the rice, he stood there in front of her to see that she wanted for nothing. Then he went to the door with the baby at his shoulder, like a wet-nurse; and to anybody who asked him, as they were passing, he replied: "It's a girl, neighbour! Bad luck follows me even here, and I've got a girl born to me. My wife couldn't do any better than that."

And when Red-head got knocks from her husband, she turned round on her sister-in-law, who never did a hand's turn to help in the house, and Lucia flew back at her saying that without having any husband of her own she'd got all the burden of other folk's children foisted on her. The mother-in-law, poor thing, tried to make peace in these quarrels, repeating: "It's my fault, I'm no good for anything now. I

eat idle bread, I do."

She was no good for anything but to hear all those miseries, and to brood over them inside herself; Santo's difficulties, his wife's crying, the thought of her other son far away, a thought that stuck in her heart like a nail; Lucia's bad temper, because she hadn't got a rag of a Sunday frock and never saw so much as a dog pass under her window. On Sundays, if they called her to join the group of gossips who were chattering in the shadow, she replied with a shrug of the shoulders: "What do you want me to come for? To show you the silk frock I haven't got?"

Sometimes however Pino the Tome, him of the frogs, would join the group of neighbour women, though he never opened his mouth, but stood with his back to the wall and his hands in his pockets, listening, and spitting all over the place. Nobody knew what he came for; but when Neighbour Lucia appeared in the doorway, Pino looked at her from under his eyes, pretending to be turning to spit. And at evening, when all the street doors were shut, he went so far as to sing her little songs outside the door, making his own bass for himself — huum! huum! huum! Sometimes the young fellows of the village going home late, recognizing his voice would strike up the frog tune, to mock him.

Meanwhile Lucia pretended to be busying herself about the house, as far as possible from the light, her head sunk, so that they shouldn't see her face. But if her sister-in-law grumbled, "There goes the music!" she turned round like a viper to retort: "Even the music is a trouble to you, is it? In this galley-hole there musn't be anything for eyes to see nor ears to hear, my word!"

The mother who noticed everything, and who was also listening, watching her daughter, said that as far as she was concerned that music made her feel happy inside herself. Lucia pretended not to understand anything. Yet every day, at the time when the frog fellow was due to be passing, she did not fail to be standing in the doorway with her distaff in her hand. The Tome, as soon as he got back from the river, went round and round the village, always returning to that particular quarter, with the remains of his frogs in his hand,

117

crying, "Song-fish! song-fish!" As if the poor folks of those mean streets could afford to buy song-fish!

"But they must be good for sick people!" said Lucia, who was dying to get a start bargaining with the Tome. But the mother wouldn't let them spend money on her.

The Tome, seeing Lucia watching him from under her eyes, her chin on her breast, slackened his pace before the door, and on Sunday he summoned enough courage to draw a little nearer, till he came so far as to sit on the steps of the next terrace, with his hands hanging between his thighs; and he told all the women in the group about how you caught frogs, how it needed the devil's own cunning. He was more cunning than a red-haired ass, was Pino the Tome, and he waited till the goodwives had gone away to say to Neighbour Lucia, "We want rain badly for the corn, don't we!" Or else, "Olives will be scarce this year!"

"What does that matter to you? You live by your frogs," Lucia said to him.

"You hark here, my dear friend; we are all like the fingers on one hand; or like the tiles on the roof of the house, one sending water to the other. If there's no crop of corn or of olives, there'll be no money coming into the village, and nobody will buy my frogs. You follow what I mean?"

That "my dear friend" went sweet as honey to the heart of the girl, and she thought about it all evening long as she was spinning silently beside the lamp; and she turned it round and round in her mind, like her spool that spun from her fingers.

The mother seemed as if she read into the secrets of the distaff, and when for a few weeks no more songs had been heard in the evening, and the frog-seller had not been seen going past, she said to her daughter-in-law: "How miserable the winter is! We don't hear a living soul in the neighbourhood."

Now they had to keep the door shut, for the cold, and through the little opening they never saw a thing except the window of the house across the road, black with rain, or some neighbour going home in his soaking wet cloak. But Pino the Tome never showed his face, so that if a poor sick

person wanted a drop of frog broth, said Lucia, there was no telling how you were going to get it to her.

"He'll have gone to earn his bread some other road," said the sister-in-law. "It's a poor trade, that is, and nobody would follow it who could do anything else."

Santo, who had heard the chatter on Saturday evening, made his sister the following speech, out of love for her: "I don't like this talk about the Tome. He'd be a fancy match for my sister! A man who lives on frog-catching, and stands with his legs in the wet all day long! You ought to get a man who works on the land, so that even if he owned nothing, at least he'd be drawn from the same class as yourself."

Lucia was silent, her head lowered and her brows knit, biting her lips from time to time so as not to blurt out: "And where am I going to find a man who works on the land?" How indeed was she to find him, all by herself? The only one she had managed to find now never showed his face any more, probably because Red-head had played her some nasty trick, envious, tattling creature that she was. There was Santo who never said anything but what his wife said, and she, the Red-head, had gone round repeating that the frog man was a good-for-nought, which bit of news of course had come to the ears of Neighbour Pino.

Therefore squabbles broke out every moment between the two sisters-in-law.

"The mistress here isn't me, that it isn't," grumbled Lucia. "The mistress in this house is the one who was clever enough to wheedle round my brother and snap him up for a husband."

"If I'd only known what was coming I'd never have wheedled round him, I wouldn't, brother or no brother; because if I needed one loaf of bread before, now I need five."

"What does it matter to you whether the frog-catcher has got a proper trade or not? If he was my husband, it would be his business to look after keeping me."

The mother, poor thing, came between them to soothe them down; but she was a woman of few words, and she didn't know what to do but run from one to the other,

clutching her hair with her hands, stammering:

"For mercy's sake! for mercy's sake!"

But the women took not the slightest notice of her, setting their nails in each other's faces after Red-head had called Lucia that bad word, "Nasty-cat!"

"Nasty-cat yourself! You stole my brother from me!"

Then arrived Santo, and gave both of them knocks to quiet them, so that Red-head, weeping, grumbled: "I say it for her own good! because if a woman marries a man who's got nothing, troubles come fast enough."

And to his sister, who was screaming and tearing her hair, Santo said, to quiet her: "Well what do you expect, now that she is my wife? But I'm fond of you and I speak for your own sake. You see what a lot of good we've done ourselves by getting married, us two!"

Lucia lamented to her mother: "I want to do as much good for myself as they've done for themselves! I'd rather go out to service! If a mortal man does show his face round here, they drive him away." And she thought about the frog-catcher of whom there was never a sign nowadays.

Afterwards they got to know that he had gone to live with the widow of Farmer Mariano; even that he was thinking of getting married to her; because though it was true he hadn't got a proper trade, he was none the less a fine piece of a young fellow, built without any sparing of material, and as handsome as San Vito in flesh and blood, that he was; and the lame woman had property enough to be able to take what husband she liked and chose.

"Look at this, Neighbour Pino," she said. "This is all white things, linen and everything, these are all gold ear-rings and necklaces; in this jar there are twelve gallons of oil; and that section is full of beans. If you like you can live with your hands in your pockets, and you needn't stand up to your knees in the marsh catching frogs."

"I should like it all right," said the Tome. But he thought of Lucia's black eyes looking for him under the cotton panes of the window, and then of the hips of the lame woman, which woggled like a frog's as she went about the house showing him all her stuff. However, one day when he hadn't

been able to get a scrap of anything for three days and had had to stay in the widow's house, eating and drinking and watching the rain fall outside the door, he persuaded himself to say yes, out of love for daily bread.

"It was for the sake of my daily bread, I swear to you," he said with his hands crossed on his breast, when he came back to look for Neighbour Lucia outside her door. "If it hadn't been for the hard times, I wouldn't have married the lame woman, I wouldn't, Neighbour Lucia!"

"Go and tell that to the lame woman herself," replied the girl, green with bile. "I've only got this to say to you; you don't set foot here any more."

And the lame woman also told him that he wasn't to set foot there any more, for if he did she'd turn him out of her house, naked and hungry as when she had taken him in. "Don't you know that, even more than to God, you're obliged to me for the bread you eat?"

But as her husband he went short of nothing: well clad, well fed, with shoes on his feet and nothing else to do but lounge in the market-place all day, at the greengrocer's, at the butcher's, at the fishmonger's, with his hands behind his back and his belly full, watching them buy and sell.

"That's his real trade, being a vagabond!" said Red-head. And Lucia gave it her back again, saying that if he did nothing it was because he'd got a rich wife who kept him. "If he'd married *me* he'd have worked to keep his wife." Santo, with his head in his hands, was thinking how his mother had told him to take the lame woman himself, and how it was his own fault it he'd let the bread slip from his mouth.

"When we're young," he preached to his sister, "we have these notions in our heads, like you have now, and we only think of pleasing ourselves, without counting what comes after. Ask Red-head now if she thinks folks ought to do as we have done."

Red-head, squatting on the threshold, shook her head in agreement with him, while her brats squealed round her, pulling her by the dress and the hair.

"At least the Lord God shouldn't send the plague of children," she said fretfully.

As many children as she could she took with her to the field, every morning, like a mare with her foals; the least one inside the bag over her shoulder, and the one a bit bigger she led by the hand. But she was forced to leave the other three at home, to drive her sister-in-law crazy. The one in the sack and the one that trotted limping behind her screamed in concert the length of the rough road, in the cold of the white dawn, and the mother had to pause from time to time, scratching her head and sighing: "Oh, my Lord!" And she breathed on the tiny blue hands of the little girl, to warm them, or she took the baby out of the sack to put it to her breast as she walked. Her husband went in front, bent under his load, and if he turned half round, waiting to give her time to overtake him, all out of breath as she was, dragging the little girl by the hand, and with her breast bare, it wasn't to look at the hair of Red-head, or at her breast which heaved inside her stays, like at Castelluccio. Now Red-head tipped out her breast in sun and frost, as if it served for nothing more except to give out milk, exactly like a mare. A real beast of burden, though as far as that went her husband could not complain of her: hoeing, mowing, sowing, better than a man, when she pulled up her skirts, and was black half-way up her legs, on the corn-land. She was twenty-seven years old now, with something else to do besides think of thin shoes and blue stockings. "We are old," said her husband, "and we've got the children to think of." But anyhow they helped one another like two oxen yoked to the same plough, which was what their marriage amounted to now.

"I know only too well," grumbled Lucia, "that I've got all the trouble of children, without ever having a husband. When that poor old woman shuts her eyes at last, if they want to give me my bit of bread they'll give it, and if they don't they'll turn me out on to the street."

The mother, poor thing, didn't know what to answer, and sat there listening to her, seated beside the bed with the kerchief round her head and her face yellow with illness. During the day she sat in the doorway, in the sun, keeping still and quiet till the sunset paled upon the blackish roofs opposite, and the goodwives called the fowls to roost.

Only, when the doctor came to see her, and her daughter put the candle near her face, she asked him, with a timid smile:

"For mercy's sake, your honour, is it a long job?"

Santo, who had a heart of gold, replied: "I don't mind spending money on medicine, so long as we can keep the poor old mother here with us, and I can know I shall find her in her corner when I come home. Then she's worked her share, in her own day, and when we are old our children will do as much for us."

And then it happened that Carmenio had caught the fever at Camemi. If the master had been rich he'd have bought him medicine; but Herdsman Vito was a poor devil who lived on that bit of a flock, and he kept the boy really out of charity, for he could have looked after that handful of sheep himself, if it hadn't been for fear of the malaria. But then he wanted to do the good work of giving bread to Neighbour Nanni's orphan, hoping by that means to win over Providence to his help, as it ought to help him, if there was justice in heaven. How was it his fault if he owned nothing but that bit of grazing land at Camemi, where the malaria curdled like snow, and Carmenio had caught the ague? One day when the boy felt his bones broken by the fever, he let himself sink asleep behind a rock which printed a black shadow on the dusty little road, while heavy flies were buzzing in the sultry air of May, and in a minute the sheep broke into the neighbour's corn, a poor little field as big as a pocket-handkerchief, already half eaten up by the hot drought. Nevertheless uncle Cheli, who was curled up under a little roof of boughs, cherished it like the apple of his eye, that corn-patch that had cost him so much sweat and was the hope of the year for him. Seeing the sheep devouring him, he cried: "Ah! You Christians don't eat bread, don't you?"

And Carmenio woke up under the blows and kicks of Uncle Cheli, and began to run like a madman after the scattered sheep, weeping and yelling. Carmenio, who had his bones already broken by the ague, stood badly in need of the cudgelling! But he thought, did he, that he could pay in squeals and laments for the damage done to his neighbour?

"A year's work lost, and my children without bread this winter! Look at the damage you've done, you assassin! If I skin you alive it won't be as much as you deserve."

Uncle Cheli went round getting witnesses to go to law with the sheep of Herdsman Vito. The latter, when he was served with the summons, felt as if he was struck with paralysis, and his wife as well. "Ah, that villain of a Carmenio has ruined us all! You do somebody a good turn, and this is how they pay you back! Did he expect me to stop there in all the malaria and watch the sheep? Now Uncle Cheli will finish us off into poverty, making us pay costs." The poor devil ran to Camemi at midday, blinded by despair, because of all the misfortunes which were raining down on him, and with every kick and every punch on the jaw he fetched Carmenio he stammered, panting: "You've brought us down to nothing! You've landed us in ruin, you brigand!"

"Don't you see how sick I am?" Carmenio tried to answer, parrying the blows. "How is it my fault, if I couldn't stand on my feet with fever? It got me unawares, there, under the rock."

None the less he had to make up his bundle there and then, and say good-bye to the five dollar-pieces which were due to him from Herdsman Vito, and leave the flock. And Herdsman Vito was downright glad to catch the fever again, he was so overwhelmed by his troubles.

Carmenio said nothing at home, when he came back empty-handed and empty-bellied, with his bundle on a stick over his shoulder. Only his mother grieved at seeing him so pale and wasted, and didn't know what to think. She learned everything later from Don Venerando, who lived just near and had also land at Camemi, next to the field of Uncle Cheli.

"Don't you tell anybody why Uncle Vito sent you away," said the mother to her boy. "If you do, nobody will take you on as a hired lad." And Santo added as well: "Don't say anything about having tertian fever, because if you do nobody will want you, knowing you're ill."

However, Don Venerando took him for his flock at Santa Margherita, where the shepherd was robbing him right and left, and doing him more hurt even than the sheep in the

corn. "I'll give you medicine myself, and so you'll have no excuse for going to sleep, and letting the sheep rove where they like."

Don Venerando had developed a kindly feeling towards all the family, out of love for Lucia, whom he used to see from his little terrace when he was taking the air after dinner. "If you like to give the girl as well I'll give her half a dollar a month." And he said moreover that Carmenio could go to Santa Margherita with his mother, because the old woman was losing ground from day to day, and with the flock she would at any rate not lack for eggs, and milk, and a bit of mutton broth, when a sheep died. Red-head stripped herself of the best of anything she had worth taking, to get together a little bundle of white washing for the old woman. It was now sowing time, and they couldn't come and go every day from Licciardo, and winter, the season of scarcity of everything, would be on them again. So now Lucia said she absolutely would go as servant in the house of Don Venerando.

They put the old woman on the ass, Santo on one side and Carmenio on the other, and the bundle behind; and the mother while she let them have their way with her, said to her daughter, looking at her with heavy eyes from her blanched face: "Who knows if we shall ever see one another again? Who knows if we shall ever see one another again? They say I shall come back in April. You live in the fear of the Lord, in your master's house. Anyhow you'll want for nothing there."

Lucia sobbed in her apron, and Red-head did the same, poor thing. At that moment they had made peace, and held their arms round one another, weeping together.

"Red-head has got a good heart," said her husband. "The trouble is we aren't rich enough to be always fond of one another. When hens have got nothing else to peck at in the fowl-house, they peck at one another."

Lucia was now well settled in Don Venerando's house, and she said she never wanted to leave it till she died, as folks always say, to show their gratitude to the master. She had as much bread and soup as she wanted, a glass of wine every

day, and her own plate of meat on Sundays and holidays. So that her month's wages lay in her pocket untouched, and at evening she had also time to spin herself linen for her dowry on her own account. She had already got the man ready to hand, there in the selfsame house: Brasi the kitchen-man who did the cooking and also helped in the fields when necessary. The master had got rich in the same way, in service at the baron's, and now he was a Don, and had farmland and cattle in abundance. Because Lucia came from a respectable family that had fallen on evil days, and they knew she was honest, they had given her the lighter jobs to do, to wash the dishes, and go down into the cellar, and look after the fowls; with a cupboard under the stairs to sleep in, quite like a little bedroom, with a bed and a chest of drawers and everything; so that Lucia never wanted to leave till she died. Meanwhile she turned her eyes on Brasi, and confided to him that in two or three years she'd have a bit of savings of her own and would be able to "go out into the world," if the Lord called her.

Brasi was deaf in that ear. But Lucia pleased him, with her eyes as black as coals, and the good flesh she had on her bones, and for her part she liked Brasi too; a little, curly-headed fellow with the delicate cunning face of a little fox-dog. While they were washing dishes or putting wood under the boiler he invented every kind of roguery to make her laugh, as if he was trying to rouse her up. He squirted water on to the back of her neck, and stuck endive leaves in her hair. Lucia squealed subduedly, so that the masters shouldn't hear; she took refuge in the corner by the oven, her face as red as fire, and she threw dish-rags and twigs in his face, whilst the water trickled down her back like a thrill.

"With meat you make rissoles—I've made mine, you make yours."

"I won't," replied Lucia. "I don't like these jokes."

Brasi pretended to be mortified. He picked up the leaf of endive which she had thrown at him, and stuck it in his bosom, inside his shirt, grumbling: "This belongs to me. I don't touch you. It belongs to me and is going to stop here. Don't you want something from me, to put in the same

place, you?" And he pretended to pull out a handful of his hair to offer her, sticking out the length of his tongue as he did so.

She punched him with the solid punches of a peasant woman, which made him hunch up his back, and gave him bad dreams at night, he said. She seized him like a dog by the hair, and found a certain pleasure in thrusting her fingers in that soft, curly wool.

"Keep it up! Keep it up! I'm not touchy like you, and I'd let myself be pounded to sausage-meat by your hands."

One day Don Venerando caught him at these games, and made the devil of a row. He wasn't going to have carryings-on in his house; he'd kick them both out if there was any more of it. And yet when he found the girl alone in the kitchen he took her by the chin and wanted to caress her with two fingers.

"No! no!" replied Lucia, "I don't like those sort of carryings-on. If you don't leave me alone I'll get my things and go."

"You like them from him all right, you like them from him. And yet not from me who are your master? What do you mean by it? Don't you know I can give you gold rings and gold earrings with pendants, and make you up your dowry if I like."

Certainly he could, Brasi assured her, for the master had any amount of money, and his wife wore a silk mantle like a lady, now that she was old and thin as a mummy, for which reason her husband came down to the kitchen to have his little joke with the maids. And he came as well to watch his own interest, how much wood they burnt, and how much meat they were putting down to roast. He was rich, yes, but he knew what it cost to get property together, and he quarrelled all day long with his wife, who had no end of vanities in her head, now that she played the lady, and had taken to complaining of the smoke from the faggots and the nasty smell of onions.

"I want to gather my dowry together with my own hands," retorted Lucia. "My mother's daughter wants to remain an honest girl, in case any Christian should ask her to

be his wife."

"Remain it then!" replied her master. "You'll see what a grand dowry it will be, and how many men will come after your honesty!"

If the macaroni was a little over-cooked, if Lucia brought to table a couple of fried eggs that smelled a bit singed, Don Venerando abused her thoroughly, quite another man in his wife's presence, with his stomach stuck out and his voice loud. Did they think they were making swill for the pigs? With two servants in the kitchen sending everything to rack and ruin! Another time he'd throw the dish in her face! The mistress, blessed dear, didn't want all that racket, because of the neighbours, and she sent away the servant, squealing in falsetto: "Be off into the kitchen; get out of here, you jackanapes! you wastrel!"

Lucia went to cry her eyes out in the corner by the oven, but Brasi consoled her, with that tricky face of his.

"What does it matter? Let them rattle! If we took any notice of the masters it would be poor us! The eggs smelt burnt? All the worse for them! I can't split the wood in the yard and turn the eggs at the same time. They make me do the cooking and the outside work as well, and then they expect to be waited on like the king. I should think they've forgotten the days when he used to eat bread and onion under an olive tree, and she used to go gleaning corn."

Then servant-maid and cook discussed their "misfortunes," born as they were of "respectable people," and their parents were richer than the master, once upon a time. Brasi's father was a cart-builder, no less, and it was the son's own fault if he hadn't wanted to follow the same trade, but had taken it into his head to go wandering round the fairs, following the cart of the travelling draper, and it was then he had learnt to cook and look after a horse and cattle.

Lucia recommended the litany of her woes — her father, the cattle, Red-head, the bad harvest — both of them alike, she and Brasi, in that kitchen; they seemed made for one another.

"What, another case of your brother and Red-head?" replied Brasi. "Much obliged!" However he did not want to

128

insult her with it, straight to her face. He didn't care a rap that she was a peasant. He didn't reject her out of pride. But they were both of them poor, and it would have been better to throw themselves down the well with a stone round their necks.

Lucia swallowed that bitter pill without saying a word, and if she wanted to cry she went and hid in the stair-cupboard, or in the oven corner, when Brasi wasn't there. For she was now very fond of that Christian, what with being with him in front of the fire all day long. The reprimands and abuse of the master she took upon herself, and kept the best plate of food for him, and the fullest glass of wine, and went into the yard to chop wood for him, and had learned to turn the eggs and dish up the macaroni to a nicety. Brasi, as he saw her crossing herself, with her bowl on her knees, before she began to eat, said to her: "Have you never seen food in your life before?"

He grumbled at everything all the time; that it was a galley-slave's life, and that he had only three hours an evening to go for a walk or to go to the inn. Lucia sometimes went so far as to ask him, with her head bent and her face growing red: "Why do you go to the inn? Leave the inn alone, it's not the place for you."

"Anybody can see you're a peasant," he replied. "You folks think there's the devil in the public-house. I was born of shop-workers, masters of their trade, my dear. I am not a clod-hopper!"

"I say it for your good. You spend all your money, and besides there's always a chance of you starting a quarrel with somebody."

Brasi felt himself soften at these words, and at those eyes which avoided looking at him. And he allowed himself the gratification of asking:

"Well, does it matter to you, anyhow?"

"No, it doesn't matter to me. I speak for your own sake."

"Well, doesn't it get on *your* nerves, stopping here in the house all day long?"

"No, I thank the Lord I am so well off, and I wish all my own people were like me, and lacked for nothing."

She was just drawing the wine, squatting with the jug between her knees, and Brasi had come down into the cellar with her to show her a light. As the cellar was big and dark as a church, and not even a fly was to be heard in that subterranean place, only they two alone, Brasi and Lucia, he put his arm around her neck and kissed her on her coral-red mouth.

The poor lass remained overcome, as she crouched with her eyes on the jug, and they were both silent, she hearing his heavy breathing, and the gurgling of the wine. But then she gave a stifled cry, drawing back all trembling, so that a little of the red froth was spilled on the floor.

"Why what's amiss?" exclaimed Brasi. "As if I'd given you a slap on the face! It isn't true then that you like me?"

She dared not look him in the face, though she was dying to. She stared at the spilled wine, embarrased, stammering:

"Oh poor me! Oh poor me! What have I done? The master's wine!"

"Eh! let it go; he's got plenty, the master has! Listen to me rather. Don't you care for me? Say it, yes or no!"

This time she let him take her hand, without replying, and when Brasi asked her to give him the kiss back again, she gave it him, red with something that was not altogether shame.

"Have you never had one before?" asked Brasi laughing. "What a joke! You are all trembling, as if I'd said I was going to kill you."

"Yes, I do like you," she replied, "but I could hardly tell you. Don't take any notice if I'm trembling. It's because I was frightened about the wine."

"There now, think of that! You do, eh? Since when? Why didn't you tell me?"

"Since that saying we were made for one another."

"Ah!" said Brasi, scratching his head. "Let's go up, the master might come."

Lucia was all happiness since that kiss, it seemed to her as if Brasi had sealed on her mouth his promise to marry her. But he never spoke of it, and if the girl tried him on that score, he replied: "What are you bothering about? Besides,

what's the good putting our necks in the yoke, when we can be together just as if we were married."

"No, it's not the same. Now you fend for yourself and I fend for myself, but when we are married, we shall be one."

"And a lovely thing that will be, an' all! Besides, we don't belong to the same walk of life. It would be different if you had a bit of dowry."

"Ah! what a black heart you've got! No! You've never cared for me!"

"Yes, I have! And I'm ready for you for whatever you want of me; but without talking about that there —."

"No! I don't want any of that sort of thing! Leave me alone, and don't look at me any more!"

Now she knew what men were like. All liars and traitors. She didn't want to hear of it any more. She'd rather throw herself head first down the well; she wanted to become a Daughter of Mary; she wanted to take her good name and throw it out of the window! What good was it to her, without a dowry? She wanted to break her neck with that old creature her master, and get her dowry out of shame. Now that —! Now that —! Don Venerando was always hanging round her, first saying nice things and then nasty, looking after his own interests, seeing if they put too much wood on the fire, how much oil they used for frying, sending Brasi to buy a ha'porth of snuff, and trying to take Lucia by the chin, running round after her in the kitchen, on tip-toe so his wife shouldn't hear, scolding the girl for her lack of respect for him, making him run in that fashion! No! No!" She was like a mad cat. She'd rather take her things and go! "And where shall you find anything to eat? And how shall you find a husband, without a dowry? Look at these ear-rings! Then I'll give you fifty dollars for your dowry. Brasi would have both his eyes pulled out, for fifty dollars."

Ah, that black-hearted Brasi! He left her in the wicked hands of her master, which trembled as they pawed at her. Left her with the thought of her mother, who hadn't long to live; and of the bare house empty of everything except trouble, and of Pino the Tome who had thrown her over to go and eat the bread of the widow! He left her with the

temptation of the ear-rings and the fifty dollars in her head!

And the day she came into the kitchen with her face all dismayed, and the gold pendants dangling against her cheeks. Brasi opened his eyes, and said to her; "How fine you look now, Neighbour Lucia!"

"Ah! You like me in them? All right, all right!"

Brasi, now that he saw the ear-rings and the rest, strove so hard to show himself helpful and useful to her, that you might have thought she had become another mistress in the house. He left her the fuller plate, and the best seat at the fire. And he opened his heart wide to her, that they were two poor things both of them, and it did your soul good to tell your troubles to somebody you were fond of. And as soon as he could scrape fifty dollars together he'd set up a little public-house and take a wife. He in the kitchen, she behind the bar. And then you weren't at anybody's bidding. If the master liked to do them a good turn, he could do it without hurting himself, because fifty dollars was a pinch of snuff to him. And Brasi wouldn't look down his nose, not he! One hand washes the other in this world. And it wasn't his fault if he tried to earn his living as best he could. Poverty wasn't a sin.

But Lucia went red and white, her eyes swelled with tears, or she hid her face in her apron. After some time she didn't show herself outside the house, neither for mass, nor for confession, nor at Easter, nor at Christmas. In the kitchen she hid herself in the darkest corner, with her face dropped, huddled in the new dress her master had given her, wide around the waist.

Brasi consoled her with kind words. He put his arm round her neck, felt the fine stuff of her frock, and praised it. Those gold ear-rings were made for her. Anybody who is well dressed and has money in her pocket has no need to feel ashamed and walk with her eyes down; above all when the eyes are as lovely as Neighbour Lucia's . The poor thing took courage by looking into his face with those same eyes, still overcome, and she stammered: "Do you mean it, Master Brasi? Do you still care for me?"

"Yes, yes, I do really!" replied Brasi, with his hand on his conscience. "But is it my fault if I'm not rich enough to

marry you? If you'd got ten pounds, I'd marry you with my eyes shut."

Don Venerando had now taken to liking him also, and gave him his left-off clothes and his broken boots. When he went down into the cellar he gave him a good pot of wine, saying to him:

"Here, drink my health!"

And his fat belly shook with laughing, seeing the grimaces which Brasi made, and hearing him stuttering to Lucia, pale as a dead man: "The master is a gentleman, Neighbour Lucia! Let the neighbours cackle, they're all jealous, because they're dying with hunger, and they'd like to be in your shoes."

Santo, the brother, heard the gossip in the square some month or so later. He ran to his wife, staggered. Poor they had always been, but honoured. Red-head was overwhelmed, and she ran in dismay to her sister-in-law, who couldn't utter a word. But when she came back home, she was quite different, serene and with roses in her cheeks.

"If you did but see! A chest as high as this, full of white goods! and rings, and pendant-ear-rings, and necklaces of fine gold. Then there are fifty dollars for the dowry. A real God's provision!"

"And what by that?" the brother kept saying from time to time, unable to take it all in. "At least she might have waited till our mother had closed her eyes!"

All this took place in the year of the snow, when a good many roofs fell in, and there was a great mortality among the cattle of the district, God preserve us!

At Lamia and on the Mount of Santa Margherita, as folks saw that livid evening declining, heavy with ill-omened clouds, so that the oxen looked suspiciously behind them, and mooed, all the people stood outside their huts to gaze far off towards the sea, with one hand over their eyes, not speaking. The bell of the Old Monastery, at the top of the village, was ringing to drive away the bad night, and on the Castle hill-crest there was a great swarming of goodwives, seen black against the pale sky-rim, watching the Dragon's Tail in the sky, a pitch-black stripe that smelled of sulphur,

they said, and which meant it was going to be a bad night. The women made signs with their fingers to conjure him away, the dragon, and they showed him the little medal of the Madonna on their bare breasts, and spat in his face, making the sign of the cross upon themselves right down to their navels, and praying God and the souls in purgatory, and Santa Lucia, whose eve it was, to protect their fields, their cattle, and also their men, all live creatures that were outside the village. At the beginning of winter Carmenio had gone with the flock to Santa Margherita. His mother wasn't well that evening, and tossed in her bed, with her dilated eyes, and wouldn't keep quiet like she usually did, but wanted this, and wanted that, and wanted to get up, and wanted them to turn her over on to the other side. Carmenio had run round for a while, attending to her, trying to do something. Then he had posted himself by the bed, stupefied, with his hands clutching his hair.

The hut was across the stream, in the bed of the valley, between two great rocks which leaned over the roof. Opposite, the coast, seeming to stand on end, was beginning to fade in the darkness which was rising from the valley, naked and black with stones, and between the stones the white stripe of the road-track lost itself. When the sun was setting the neighbours had come from the flock in the cactus-grove, to see if the sick woman wanted anything; but she was lying quite still in her bit of a bed, with her face upwards and her nose going black, as if dusted with soot.

"A bad sign!" Herdsman Decu had said. "If I hadn't got the sheep up above, and the bad weather that's coming on, I wouldn't leave you alone tonight. Call me, if there's anything!"

Carmenio said yes, with his head leaning against the door post; but seeing him going away step by step, to be lost in the night, he had a great desire to run after him, to begin to shout, and tear his hair — to do he knew not what.

"If anything happens," shouted Herdsman Decu from the distance, "run up to the flock in the cactus thicket, up there, there's people there."

The flock was still to be seen on the rocky height,

134

skywards, in that dim of twilight which still gathered on the tops of the mountains, and penetrated the thickets of the cactus. Far, far away, towards Lamia and the plain, was heard the howling of dogs — waow! waow! waow! — the sound coming right up to there and making your bones turn cold.

Then the sheep suddenly were possessed and began to rush about in a mass in the enclosure, driven by a mad terror, as if they heard the wolf in the neighbourhood; and at that frantic clanging of sheep-bells, it seemed as if the shadows had become lit up with so many fiery eyes, all going round. Then the sheep stopped still, huddled close together, with their noses down to the ground, and the dog with one long and lamentable howl, left off barking, seated there on his tail.

"If I'd known," thought Carmenio, "it would have been better to tell Herdsman Decu not to leave me alone."

Outside , in the darkness, the bells of the flock were heard shuddering from time to time. Through the window-hole you could see the square of the black doorway, black as the mouth of an oven; nothing else. And the coast away opposite and the deep valley and the plain of Lamia, all was plunged in that bottomless blackness, so that it seemed as if what you saw was nothing but the noise of the torrent, away below, mounting up towards the hut, swollen and threatening.

If he had known this too he'd have run to the village before it got dark, to fetch his brother; and then of course by this time he'd have been there with him, and Lucia as well, and the sister-in-law.

Then the mother began to speak, but you couldn't make out what she said, and she kept grasping the bedclothes with her wasted hands.

"Mamma! Mamma! What do you want?" asked Carmenio. "Tell me what it is, I'm here with you!"

But the mother did not answer. She shook her head instead, as if to say no! no! she didn't want to. The boy put the candle under her nose and burst out crying with fear.

"Oh, mamma! oh, mamma!" whimpered Carmenio.

"Oh, I'm all alone and I can't help you!"

He opened the door to call the folks from the flock among the cactus. But nobody heard him.

Everywhere there was a dense glimmer; on the coast, in the valley, and down on the plain — like a silence made of cotton wool. All at once came the sound of a muffled bell from far off — 'nton! 'nton! 'nton! — and it seemed to curdle in the snow.

"Oh, holiest Madonna!" sobbed Carmenio. "Whatever bell is that? Oh, you with the cactus sheep, help! Help! Holy Christians!" he began to shout.

At last, above there, at the top of the cactus hill, was heard a far-off voice, like the bell of Francoforte.

"Ooooh! — what's a - m a a a t t e r? what's a-maaatter?"

"Help, good Christians! help, here at Shepherd Decu-u-u's —"

" Ooooh — follow the shee-eeep! — fo-o-ollow!"

"No! No! it isn't the sheep — it *isn't*!"

Just then the screech-owl flew past and began to screech over the hut.

"There!" murmured Carmenio, crossing himself. "Now the screech-owl has smelt the smell of dead people. Now my mamma is going to die!"

Having to stay alone in the cabin with his mother, who no longer spoke, made him want to cry. "Mamma, what's a-matter? Mamma, tell me! Mamma, are you cold?" She did not breathe, her face was dark. He lit the fire between the two stones of the hearth, and sat watching how the boughs burned, how they made a flame and then breathed out as if they were saying something about it.

When he had been with the flocks at Resecone, the Francoforte man, as they sat up at night, had told tales of witches who ride on broom-sticks, and do witchcraft over the flames of the hearth. Carmenio remembered even now how the farm-people had gathered to listen, with all their eyes open, in front of the little light hung to the pillar of the great dark mill-stone, and that not one of them had had the courage afterwards to go and sleep in his own corner that evening.

Against these things he had the medal of the Madonna

under his shirt, and the ribbon of Santa Agrippina tied round his wrist, till it had become black with wear. And in his pocket he had the reed whistle, which reminded him of summer evenings — *Yoo! Yoo!* — when they let the sheep into the stubble that is yellow as gold, and the grass-hoppers explode in sound at the hour of noon, and the larks fall whistling to nestle behind the sods at sunset, when the scent of wild-mint and marjoram wakes up. *Yoo! Yoo! infant Jesu!* At Christmas, when he had gone to the village, that was how they had played for the novena in front of the little altar that was lit up and adorned with boughs of orange-tree; and in front of the doors of all the houses the children had been playing chuck-stone, the fine December sun shining on their backs. Then they had all set off for the midnight mass, in a crowd with the neighbours, colliding and laughing through the dark streets. Ah, why had he got this thorn in his heart now? And why didn't his mother say anything! It still wanted a long time to midnight. Between the stones of the unplastered walls it seemed as if there were eyes watching from every hole, looking into the hut, at the hearth, eyes black and frozen.

On a straw-stack in a corner a jacket was thrown down, spread out long, and it seemed as if the sleeves were swelling out; and the devil with the Archangel Michael, in the image-card stuck on to the bed-head, gnashed his white teeth, with his hands in his hair, among the red zigzags of hell.

Next day, pale as so many corpses, arrived Santo, and Red-head with the children trailing after her, and Lucia who had no thought for concealing her condition, in that hour of anguish. Around the bed of the dead woman they tore their hair and beat their heads, and thought of nothing else. Then as Santo noticed his sister with so much stomach on her that it was shameful, he began saying in the midst of all the blubbering: "You might at least have let that poor woman close her eyes first, you might —."

And Lucia on her side:

"If I'd only known, if I'd only known! She shouldn't have gone short of doctor or druggist, now I've got fifty dollars of my own."

"She is in Paradise praying to God for us sinners," concluded Red-head. "She knows you've got your dowry and she's at peace, poor thing. Now Master Brasi will marry you without fail."

THE GENTRY

THEY know how to read and write — that's the trouble. The white-frost of dark winter dawns and the burning dog-days of harvest time fall upon them as upon every other poor devil, since they're made of flesh and blood like their fellow-men, and since they've got to go out and watch to see that their fellow-man doesn't rob them of his time and of his day's pay. But if you have anything to do with them, they hook you by your name and your surname, and the names of those that begot you and bore you, with the beak of that pen of theirs, and then you'll never get yourself out of their ugly books any more, nailed down by debt.

"You still owe two bushels of corn from last year."

"Sir, the harvest was bad."

"Is it my fault if it doesn't rain? Perhaps I ought to have watered your corn with my drinking glass?"

"Oh sir, I put my very blood into your land."

"That's what I pay you to do, rascal! I pay you blood for blood. I bleed myself in expenses for the agricultural outlay and then if there comes a bad season, you leave me stuck with the land, while you go off with the sickle under your arm."

And then they say, "A beggar is better off than a proprietor," because you can't take the skin off his back to pay his debts with. That's why the man who has got nothing is forced to pay dearer for his land than others — the owner risks more — and if the harvest turns out poor the half-

profits peasant naturally gets none of it, but has to go off with his sickle under his arm. But it is a nasty business, for all that, going off like that after a year's hard work, and with the prospect of a long winter in front of you, with no bread to eat.

Bad times will put the devil into any man. One time, at harvest, such a harvest that you'd think it had been excommunicated by God Himself, the friar on his begging-round rode into Don Piddu's field, kicking his fine bay mule in the belly with his wooden-soled sandals and shouting from the distance, "Hail Jesu and Mary!"

Don Piddu was sitting on a caved-in hamper sadly looking at his meagre threshing-floor, in the midst of the burnt-up stubble of the field, under that sky of fire which he didn't even feel upon his bare head, he was in such a state of despair.

"Oh, the fine bay mule you've got, Fra Giuseppe! She's worth more than all those four old nags put together, that have nothing to thresh and nothing to eat!"

"It's the collections mule," replied Fra Giuseppe. "Praise be to charity towards a fellow-man. I've come round to make the collection."

"Lucky for you who reap without sowing, and who go down to your refectory when the bell rings, and eat your fellow-man's charity! I've got five children, and have to find bread for the lot of them. Look what a grand harvest! Last year you got half a measure of corn out of me because St. Francis had sent me a good crop, and the thanks I get for it is that it hasn't rained anything but fire out of the sky for three months."

Fra Giuseppe wiped the sweat from his own face with his pocket handkerchief.

"Are you hot, Fra Giuseppe? Then I'll see you get something to cool you, I will!"

And he got four other peasants who were as enraged as himself to give the friar a sousing, turning the creature's long gown over his pate and pouring bucketfuls of green water over him out of the water-hole.

"Deuce and damnation!" shouted Don Piddu. "Since it

isn't any good giving charity to Christ, I'm going to give it to the devil, next time."

And after that he wouldn't have any more Capucin friars round his threshing floor, and was satisfied if the brother of St. Francis of Paola came to make the collection.

Brother Giuseppe put it away in his memory box: "Ah! you wanted to see my drawers, did you, Don Piddu? I'll see you without either drawers or shirt."

He was a great lump of an ugly friar with a mass of beard, and a great thick neck on him as black as a Modica bull, for which reason he was the oracle of the goodwives and the peasants in all the yards and along all the country roads.

"You musn't have anything to do with Don Piddu. Let me tell you he is excommunicated by God, and his land is accursed!"

When the mission preachers came, in the last day of Carnival, for the spiritual discipline of Lent, if there happened to be any sinner or woman of ill repute in the village, or any other merry person, they went to preach outside his door, in a procession and with the scourge round their necks, for the sins of others. Then Fra Giuseppe pointed out the house of Don Piddu, saying that now nothing went well with him: failure of crops, mortality among his cattle, his wife sick, his daughters all marriageable, handsome and ready. Donna Saridda, the eldest, was almost thirty, and was still called Donna Saridda so that she shouldn't grow up so fast. At the little party at the mayor's on Shrove Tuesday, she had at last laid hold of a swain, because Pietro Macca, peeping out of the servant's hall, had seen her clasping hands with young Don Giovannino, while they were twirling and figuring in the quadrille. Don Piddu had denied himself the bread of his mouth to take his daughter to the party in a silk dress open in front as low as her heart. Who knows! Straightway came the mission preachers outside the mayor's street door, preaching against temptations, because of all the sin that was going on inside, and the mayor had to have the windows shut to save his glass from being smashed with stones by the

people outside.

Donna Saridda went home as pleased as could be, as if she had got the first prize in the lottery safe in her pocket; and she never slept all night, for thinking about Don Giovannino, little suspecting that Fra Giuseppe was saying to him: "Are you mad, your honour, to be entering the family of Don Piddu, when you know he'll be sold up before long!"

Don Giovannino didn't care about the dowry. But the dishonour of the selling up was another pair of shoes. People crowded outside Don Piddu's door to see them carrying out the cupboards and the chests of drawers, which left a white mark upon the wall against which they had stood for so long, and the daughters, pale as wax, had a great job to hide what was happening from their mother, who was ill in bed. She, poor thing, pretended not to know. She had gone beforehand with her husband to beg and beseech first the lawyer, then the magistrate. "We'll pay tomorrow — we'll pay the day after tomorrow." And they had come back home creeping along close to the wall, she with her face hidden in her cloak — for she was of baronial blood! The day of the sale Donna Saridda, with tears in her eyes, had gone to shut all the windows, because even those who are born with Don before their names are subject to shame. Don Piddu, when out of charity they had taken him as overseer of the fields of Fiumegrande, at harvest time, when malaria ate up every Christian that came near, he didn't care about the malaria; he only grieved because now, when the peasants disputed with him, they left out the Don and called him plainly *thou.*

But while he has his arms and his health a poor devil can at least earn his bread. Which is what Don Marcantonio Malerba said when he fell into proverty, burdened with children, and his wife, always with child, was forced to go on making bread and preparing the soup and doing the washing and sweeping the rooms. Gentry need so many more things, and they're used to a different way of life. When the children of Don Marcantonio went empty-bellied all day long they never said a word, and the oldest, when his

144

father sent him to buy bread on credit, or a bundle of lettuce, went with his face lowered, at nightfall, hiding the stuff under his patched cloak.

His father turned his hand to anything he could get, in order to earn something, renting a bit of land, or taking it on the half-profits system. He came home on foot from the fields later than anybody else, wrapped in that rag of a shawl belonging to his wife, which he called a *plaid*, and he did his day's brave hoeing like any other man, when nobody was passing along the bridle-road.

Then on Sundays he went to be the gentleman along with the others in the club, prattling in a group among the rest of them with his hands in his pockets and his nose inside the collar of his overcoat; or he played at piquet with his stick between his knees and his hat on his head. At the first sound of midday they all bolted as fast as they could, some in one direction and some in another, and he also went home as if he had a dinner ready waiting for him as well. "What am I to do?" he said. "I can't go out day-labouring, with my children." And the children, now when their father sent them to ask for the loan of half a bushel of buckwheat for seed, or a peck of beans for soup, from Uncle Masi or from Farmer Pinu, they blushed and stammered as if they were already grown up.

When the fire came out of Mount Etna, destroying vineyards and olive groves, then whoever had arms to work had at least no need to starve. But for the gentry who had their land in those parts, it would have been better if the lava had buried them along with their acres, them and their children and everything. The folks who had nothing to lose went out of the village to see the fire, with their hands in their pockets. Today it had taken so-and-so's vineyard, tomorrow it would be in the fields of so-and-so; now it was threatening the bridge of the road, later it encircled the house on the right hand. Those who were not standing looking on were busying themselves removing tiles, window-frames, furniture, clearing the bedrooms, saving what they could, losing their head in the rush and the desperation of the hour, like a disturbed ant's nest.

They brought the news to Don Marco while he was at table with his family, eating a plate of macaroni.

"Signor Don Marco, the lava is coming your way, and you'll have it in your vineyards directly." At the sound of this misfortune the fork fell from his hand. The man who looked after the vineyard was carrying away the implements of the wine-press, the staves of casks, everything that could be saved, and the wife had gone to fix canes bearing images of the saints who should protect the place, at the boundaries of the vineyard, mumbling ave marias.

Don Marco arrived exhausted, driving the donkey in front of him, through the dark great cloud that rained down ashes. From the little courtyard in front of the press you could see the black mountain looming over the vineyard, smoking, collapsing here and there, with a rattling of stones as if a mountain of broken pots were slipping down, splitting open to reveal the red fire that was boiling inside it. In the distance the tallest trees shook and rustled in the still air even before they were overtaken; then they smoked and crackled; all at once they blazed and went up in a single flame. They seemed like torches lighted one by one in the dusk of the silent country, along the course of the lava. The wife of the man who looked after the vineyard went round setting a little further back the canes with the sacred images, but one by one they flared up like matches; and she cried, terrified by all that ruin, thinking that the master wouldn't need a caretaker any more, and they would be dismissed. And the watch-dog also howled before that burning vineyard. The press-house, dismantled and thrown open, roofless, with all that stuff thrown out into the courtyard, in the midst of the frightened countryside, seemed as if it trembled with fear as they removed everything from it previous to abandoning it.

"What are you doing?" Don Marco asked his man, as the latter was trying to save the casks and the implements of the wine-press. "Leave it alone. I shall have nothing left now, there'll be nothing to put in the casks."

He kissed the fence of the vineyard for the last time before abandoning it, and he turned back, leading the donkey by the halter.

In God's name! Even gentry have their troubles, and are made of flesh and blood like their neighbours. Poor Donna Maria, the other daughter of Don Piddu, had flung herself into the arms of the stable-boy, having lost all hope of ever getting married, and now they were away in the lonely country, in want and misery. Her parents had kept her without a rag of new clothes to her back, with not so much as a dog to bark after her. In the noon of a hot July day, while the flies were buzzing in the deserted farmyard, and her parents were trying to sleep, with their noses against the wall, she went to look for the lad behind the strawstacks, and he, red and stammering every time she fixed her eyes on him, seized her by the hair to give her a kiss.

Don Piddu almost died of shame. After the sale, after all the misery, he would never have thought he could sink lower. The poor mother came to know of it at the Easter communion. A saint, that woman! Don Piddu was shut up in the Capucin monastery along with all the other gentry of the place, performing the spiritual discipline of the sacred days. The gentry gathered together with their peasants to confess themselves and to hear the evangelical mission; and they paid the expenses of maintenance also, in the hope that the labourers would be converted, and that if they had robbed their masters, they would restore the ill-gotten goods. During those eight days of spiritual discipline, gentry and labourers became brothers again, as in the days of Adam and Eve; and the masters, to show their humility, waited on their farm-men at table with their own hands; so that the food went down all the wrong way, in the throats of the labourers, they were so shy and uncomfortable, and in the refectory it was like a stall of cattle, what with the noise of all those jaws working, while the evangelical preachers preached hell and purgatory. Don Piddu didn't want to go that year, not having the money to pay his share, and besides, his labourers couldn't rob anything from him. But the magistrate sent for him, and they made him turn saint by force, so that he shouldn't set a bad example. Those eight days were a godsend to anybody who had an affair on hand in the house of some poor devil, with no need to fear that the husband

might come home unexpectedly from the country to spoil the fun. The door of the monastery was closed to everybody, but the lads who had something to spend slipped out at evening and did not come back till dawn.

Now Don Piddu, after there had come to his ears certain things which Fra Giuseppe had been letting fall, got out secretly one night, as if he was but twenty years old, or as if his love-lady was waiting for him, and heaven knows what he went and discovered in his own house. Certainly when he came in again just before dawn he was pale as death, and looked a hundred years older. This time the clandestine traffic had been taken by surprise, and as the young womanisers came creeping back into the monastery, they found the mission padre kneeling outside the door, praying for the sins which others had gone out to commit. Don Piddu also threw himself on to his knees, to confess in the ear of the padre, at the same time weeping all the tears he had in his eyes.

Ah! the thing he had found out, there in his own home! in his daughter's little bedroom where not even the sun could enter! The stable-lad escaping through the window; and Maria, pale as death, trying none the less to look him in the face, and clinging with desperate arms to the door-post, to defend her lover. Then there passed before his eyes his other daughter, and his sick wife, the magistrates and the police, in a sea of blood.

"You! You!" he stammered. She trembled all over, this wretched woman, but she did not answer. Then she fell on her knees with her hands clasped, as if she read in his face that she was a parricide. And then he fled with his hands clutching his hair.

But the confessor who counselled him to offer this anguish to God, should really have said to him:

"You see, your honour, when the same trouble falls on other poor folks they keep quiet, because they are poor, and can't read and write, and can't let out what they feel without getting sent to the galleys."

LIBERTY

THEY unfurled a red-white-and-green handkerchief from the church-tower, they rang the bells in a frenzy, and they began to shout in the village square, "Hurray for liberty!"

Like the sea in storm. The crowd foamed and swayed in front of the club of the gentry, and outside the Town Hall, and on the steps of the church — a sea of white stocking-caps, axes and sickles glittering. Then they burst into the little street.

"Your turn first, baron! You who have had folks cudgelled by your estate-keepers!"

At the head of all the people a witch, with her old hair sticking up, armed with nothing but her nails. "Your turn, priest of the devil! for you've sucked the soul out of us!" "Your turn now, rich glutton, you're not going to escape no matter how fat you are with the blood of the poor!" "Your turn, police-sergeant! you who never took the law on anybody except poor folks who'd got nothing!" "Your turn, estate-keepers, who sold your own flesh and your neighbour's flesh for twenty cents a day!"

And blood smoked and went drunk. Sickles, hands, rags, stones, everything red with blood! *The gentry!* The *hat-folks!* Kill them all! Kill them all! Down with the *hat-folks!*

Don Antonio was slippling home by the short cuts. The

NOTE: Until recently only the gentle-folk wore hats in Sicily. The men-peasants wore the old Phrygian stocking-caps, the women went bareheaded or, for church, had a scarf or a shawl. The hat was a sign of class distinction.

This story is based on an actual incident in the revolution of 1860, when Garibaldi was in Sicily with the Thousand.

first blow made him fall with his bleeding face against the causeway. "Why? Why are you killing me?" "You as well, the devil can have you!" A lame brat picked up the filthy hat and spat inside it. "Down with the hats! Hurray for Liberty! You, take that!" Then for his Reverence who used to preach hell for anybody who stole a bit of bread. He was just coming back from saying mass, with the consecrated host inside his fat belly. "Don't kill me, I am in mortal sin!" Neighbour Lucia being the mortal sin; Neighbour Lucia whose father had sold her to the priest when she was fourteen years old, at the time of the famine winter, and she had ever since been filling the streets and the Refuge with hungry brats. If such dog's-meat had been worth anything that day they'd have been able to stuff themselves with it, as they hacked it to pieces with their hatchets in the doorways of the houses and on the cobblestones of the street. Like the wolf when he falls famished on a flock of sheep, and never thinks of filling his belly, but just slaughters right and left with rage — Milady's son, who had run to see what was happening — the apothecary, while he was locking up shop as fast as he could — Don Paolo, who was coming home from the vineyard riding on his ass, with his lean saddle-bags behind him. And he was wearing into the bargain a little old cap that his daughter had embroidered for him long ago, before the vines had taken the disease. His wife saw him fall in front of the street-door, as she and her five children were waiting for him and for the handful of stuff for the soup which he had got in his saddle-bags. "Paolo! Paolo!" The first fellow caught him in the shoulder with a hatchet cut. Another was on him with a sickle, and disembowelled him as he was reaching with his bleeding arm for the knocker.

But the worst was when the lawyer's son, a lad of eleven, blond as gold, fell no one knows how, overthrown in the crowd. His father had raised himself two or three times before he dragged himself aside into the filth, to die, calling to him: "Neddu! Neddu!" Neddu fled in terror, mouth and eyes wide open, unable to make a sound. They knocked him down; he also raised himself on one knee, like his father; the torrent passed over him; somebody put his great boot on the

boy's cheek and smashed it in; nevertheless the lad still begged for mercy with his hands. He didn't want to die, no, not in the way he had seen his father killed; it broke his heart! The wood-cutter out of pity gave him a great blow with the axe, using both hands, as if he had had to fell a fifty-year-old oak-tree — and he trembled like a leaf. Somebody shouted, "Bah, he'd have been another lawyer!"

No matter! Now they had their hands red with such blood, they'd got to spill the rest of it. All of 'em! All the *hats!* It was no longer hunger, beatings, swindling which made their anger boil up again. It was innocent blood. The women most ferocious of all, waving their fleshless arms, squealing in falsetto, with rage, the tender flesh showing under the rags of their clothing. "You who came praying to the good God in a silk frock!" "You who thought yourself contaminated if you knelt beside poor folks! Take that! Take that!" In the houses, on the stair-cases, inside the alcoves, a tearing of silk and of fine linen. Oh the ear-rings upon bleeding faces, oh the golden rings upon hands that tried to ward off the hatchet-strokes!

The baroness had had the great door barricaded: beams, wagons, full casks piled against it, and the estate-keepers firing from the windows to sell their lives dear. The crowd bowed its head to the gun-fire, because it had no weapons to respond with. Because in those days it was the death-penalty for having fire-arms in your possession. Hurray for Liberty! And they burst in the great doors. Then into the courtyard, up the steps, dislodging the wounded. They left the estate-keepers for the time. They would settle them later. First they wanted the flesh of the baroness, flesh made of partridges and good wine. She ran from room to room with her baby at her breast, all dishevelled — and the rooms were many. The crowd was heard howling along the twistings of the passages, advancing like a river in flood. The oldest son, sixteen years of age, also with fair white flesh still, was pushing the door with his trembling hands, crying: "Mama! Mama!" At the first rush they sent the door down on top of him. He clung to the legs which trod him down. He cried no more. His mother had taken refuge on the balcony, clasping

her baby close, shutting its mouth with her hand so that it should not cry, mad. The other son wanted to defend her with his body, glaring, as if he had a hundred hands, clutching all those axes by the blades. They separated them in a flash. One man seized her by the hair, another by her hips, another by her dress, lifting her above the balcony rail. The charcoal-man tore the infant baby from her arms. The other brother saw nothing but red and black. They trampled him down, they ground his bones with iron-shod heels; he had set his teeth in a hand which was squeezing his throat, and he never let go. Hatchets couldn't strike in the heap, they hovered flashing in the air.

And in that mad carnival of the month of July, above all the drunken howling of the fasting crowd, the bell of God kept on ringing frantically, until evening, with no midday, no ave-maria, like in the land of the Turks. Then they began to disband, tired with the slaughter, quietly, slinkingly, every one fleeing from his companion. Before nightfall all doors were shut, in fear, and in every house the lamp was burning. Along the little streets no sound was heard save that of the dogs, which went prying in the corners, then a dry gnawing of bones, in the bright moonlight which washed over everything, and showed the wide-open big doors and the open windows of the deserted houses.

Day broke: a Sunday with nobody in the square, and no mass ringing. The sexton had burrowed into his hiding hole; there were no more priests. The first comers that began to gather on the sacred threshold looked one another in the face suspiciously; each one thinking of what his neighbour must have on his conscience. Then, when they were a fair number, they began to murmur: "We can't be without mass, and on a Sunday, like dogs!" The club of the *Gentry* was barricaded up, and they didn't know where to go to get their masters' orders for the week. From the church tower still dangled the red-white-and-green handkerchief, flaccid, in the yellow heat of July. And as the shade diminished slowly outside the church-front, the crowd clustered all in one corner. Between two miserable houses of the square, at the bottom of a narrow street that sloped steeply downwards,

you could see the fields yellowish on the plain, and the dark woods on the slopes of Etna. Now they were going to share up those fields and woods among themselves. Each one was calculating to himself, on his fingers, how much he should get for his share, and was looking askance at his neighbours. Liberty meant that everybody should have his share — yon Nino Bestia and yon Ramurazzo would have liked to make out that they must carry on the bossy tricks of the *hats!* If there was no surveyor to measure the land, and no lawyer to put it on to paper, everybody would be going at it tooth and nail! And if you booze your share at the public-house, then afterwards we've got to start sharing all over again — thief here and thief there. Now that there was Liberty, anybody who wanted to eat enough for two ran the risk of being done in like those there *gentry!* The wood-cutter brandished his fist in the air as if he still grasped the axe.

The next day they heard that the General was coming to deal out justice; which news made folks tremble. They saw the red shirts of their own soldiers climbing slowly up the ravine towards the village; if you had rolled down rocks you could have squashed them all. But nobody stirred. The women screamed and tore their hair. And the dark-faced men with long beards only sat on the top of the hill with their hands between their thighs watching those tired boys come up, bent beneath their rusty rifles, and that little General on his great black horse, in front of them all, alone.

The General made them carry straw into the church, and put his boys to sleep like a father. In the morning, before dawn, if they weren't up at the sound of the bugle, he rode into the church on his horse, swearing like a Turk. That was a man! And on the spot he ordered five or six of them to be shot. Pippo, the dwarf, Pizzannello, the first one they laid hold of. The wood-cutter, while they were making him kneel against the cemetery wall, wept like a child because of certain words his mother had said to him, and because of the cry she had uttered when they tore him from her arms. From afar off, in the remotest alleys of the village as you sat behind your closed door, you could hear those gun-shots firing one after the other, like cannon-crackers at holiday time.

And then came the real judges, gentlemen in spectacles perched upon mules, done up with the journey, complaining still of their fatigue, while they were examining the accused in the refectory of the monastery, sitting on one hip on their seats, and saying aha! every time they changed the side. A trial that would never come to an end. They took the guilty over away to the city, on foot, chained two by two, between two files of soldiers with cocked muskets. Their women followed them running down the long country roads, across the fallow land, through the cactus thickets and the vineyards and the golden-coloured wheat, tired out, limping, calling out their names every time the road made a bend and they could see the faces of the prisoners. At the city they shut them up in the great prison that was high and vast as a monastery, all pierced with iron-barred windows; and if the women wished to see their men, it was only on Mondays in presence of the warders, behind the iron grating. And the poor fellows got yellower and yellower in that everlasting shadow, never seeing the sun. Every Monday they were more taciturn, and they hardly answered, they complained even less. Other days if the women roved in the square round the prison, the sentinels threatened them with their guns. And then never knowing what to do, where to find work in the town, nor how to earn bread. The bed in the stables cost two cents; the white bread they swallowed in a gulp did not fill their stomachs; and if they crouched down in the doorway of a church, to pass the night there, the police arrested them. One by one they went back home, first the wives, then the mothers. One good-looking lass lost herself in the town and was never heard of again. All the others belonging to the village had come back to do the same as they had done before. The gentry couldn't work their lands with their own hands, and the poor folks couldn't live without the gentry. So they made peace. The apothecary's orphan son stole Neli Pirru's wife, and it seemed to him a proper thing to do, to revenge himself on the one who had killed his father. And when the woman had qualms now and then, and was afraid that her husband when he came out of prison would cut her face, the apothecary's son replied,

"Don't be afraid, he won't come out." Nowadays nobody thought of them; unless it was some mother, some old father, when their eyes wandered towards the plain where the city lay, or on Sundays when they saw the others talking over their affairs quietly with the gentry, in front of the club, with their caps in their hands; and they convinced themselves that rags must suffer in a wind.

The case lasted three years, no less; three years of prison without ever seeing the sun. So that the accused seemed like so many dead men out of the tomb, every time they were conducted fettered to the court. Whoever could manage it had come down from the village, witnesses, relatives, people full of curiosity, like a holiday, to see their fellow villagers, after such a long time, crowded together in the chicken-coop of the prisoner's dock — and real chickens you became, inside there! and Neli Pirru had to see the apothecary's lad face to face, the fellow who had become his relation underhand! They made them stand up one by one. "What is your name?" And each one answered for himself, name and surname and what he had done. The lawyers fenced away with their speeches, in wide, loose sleeves, getting besides themselves, foaming at the mouth, suddenly wiping themselves calm with a white pocket-handkerchief, and snuffing up a pinch of snuff. The judges dozed behind the lenses of their spectacles, which froze your heart. Facing were seated twelve *gentry* in a row, tired, bored, yawning, scratching their beards or gabbling among themselves. For sure they were telling one another what a marvellous escape it had been for them that they weren't gentry of that village up there, when the folks had been making liberty. And those poor wretches opposite tried to read their faces. Then they went away to confabulate together, and the accused men waited white-faced, with their eyes fixed on the closed door. As they came in again, their foreman, the one who spoke with his hand on his stomach, was almost as pale as the prisoners, and he said, "On my honour and on my conscience —!"

The charcoal man, while they were putting the handcuffs on him again, stammered: "Where are you taking me to? To

the galleys? Oh, why? I never got so much as half a yard of land! If they'd told me what liberty was like —!"

ACROSS THE SEA

ACROSS THE SPA

SHE listened, wrapped up in her furs and leaning back against the outside of the cabin, her large pensive eyes staring into the vague shadows of the sea. The stars glittered above their heads, and no sound was heard around them save the heavy throb of the engines, and the moan of the waves which lost themselves upon the boundless horizon. In the bows, behind them, somebody was softly humming a popular song, to the accompaniment of the accordion.

Perhaps she was thinking of the hot emotions she had felt the previous evening at the theatre of San Carlo in Naples, or of the Chiaia foreshore blazing with light, which they had left behind them. She had loosely taken his arm, with the abandon of that isolation in which they found themselves, and had gone to lean on the ship's rail, looking at the phosphorescent stripe which the steamer made, deep under which the screw broke open unexplored abysses, as if she wanted to fathom the mystery of other unknown existences. On the opposite side, towards the land above which Orion sloped over, other unknown, almost mysterious lives quivered and suffered who knows what poor joys, poor sorrows, how like to those he was telling! The woman was thinking of them vaguely, with compressed lips, her eyes fixed on the darkness of the horizon.

Before they separated they remained a while in the cabin doorway in the wavering glimmer of the swinging lamp. The steward, tired out, was squatted asleep on the stairs,

dreaming perhaps of his little home in Genoa. In the poop the compass-light faintly lit up the muscular figure of the man at the helm, who was motionless, his eyes fixed on the quadrant and his mind who knows where. From the bows all the while came the sad Sicilian folk-song, telling in its own way of joys and sorrows, or of humble hopes, amid the monotonous moaning of the sea and the regular, impassive beat of the piston-rod.

It was as if the woman could not bring herself to let go his hand. At last she raised her eyes and smiled sadly at him.

"Tomorrow!" she sighed.

He nodded his head without speaking.

"You will never forget this last evening?"

He did not answer.

"I never shall," added the woman.

At dawn they met again on deck. Her delicate small face seemed quenched with insomnia. The breeze lifted her soft black hair. Already Sicily was rising like a cloud out of the far horizon. Then Etna all at once lit up with gold and ruby, and the paling coast broke here and there into gulfs and obscure promontories. On board the crew began to busy themselves about the first morning work. Passengers came up one by one on deck, pale, dazed, wrapped up in various ways, chewing a cigar and staggering about. The crane began to screech, and the song heard through the night was silent as if dismayed and lost in all that bustle. On the gleaming blue sea great spreading sails passed by the stern, swaying their large hulls that seemed as if they were empty, the few men on board shading their eyes to see the proud steamer go by. In the distance were other still smaller boats, like black dots, and the coast swathed in foam; on the left Calabria, and on the right the sandy Pharos Headland, Charybdis stretching her white arms towards rocky, lofty Sicily.

Unexpectedly, in the long line of the shore that seemed all one, you perceived the Straits like a blue river, and beyond, the sea again widening out once more, boundless. The woman uttered an exclamation of wonder. Then she wanted him to point out to her the mountains of Licodia and

the Plain of Catania, or the Lake of Lentini with its flat shores. He showed her far away, beyond the blue mountains, the long, melancholy lines of the whitish plain, the soft slopes grey with olives, the harsh rocks with the cactus thickets, and scented, many-planted little mountain roads. It was as if all those places were peopled with people out of a legend, as he pointed them out to her one by one. Thereabouts the malaria; on the slope of Etna the village where Liberty burst out like a vendetta; below, beyond, the humble dramas of the Mystery Play, and the ironic justice of Don Licciu Papa. As she listened she even forgot the quivering drama in which they two were acting, whilst Messina was drawing towards them with the vast semi-circle of its palace fronts. All at once she started and murmured, "There he is!"

From the land a row-boat was advancing, and in it a white handkerchief waving salutes like a white gull in a storm.

"Goodbye!" murmured the young man.

The woman did not answer, and bent her head. Then she clasped his hand fast under her furs and took a stride away from him.

"Not goodbye! Au revoir!"

"When?"

"I don't know. But not goodbye."

And he saw her offer her lips to the man who had come to meet her in the boat. Sinister visions passed through his mind, ghosts of the people in his stories, with crooked frown and knife in hand.

Her blue veil disappeared towards the shore, amid the crowd of boats and anchor-chains.

The months passed by. At last she wrote to him that he could come to her. "In a lonely little house among the vines — there will be a cross chalked on the door. I shall come by the path between the fields. Wait for me. Don't let anybody notice you, or I am lost."

It was still autumn, but it rained and blew like winter. Hidden behind the door, with his heart thudding inside him, he eagerly watched for the strokes of rain that struck furrows past the window-hole to thin down. The dry leaves

whirled behind the threshold like the rustle of a dress. What was she doing? Would she come? The clock always answered no, no , every quarter of an hour, from the neighbouring village. At last a ray of sun came through a broken tile. All the country shone. The carob trees above the roof rustled loudly, and beyond, behind the dripping avenues, the foot-path opened out blossoming with yellow and white marguerites. It was there her little white umbrella should appear, down there, above the low wall on the right. A wasp buzzed in the golden ray that penetrated through the cracks, and bumped against the window-frame saying: Come! Come! All at once somebody roughly pushed open the garden door on the left. Like a stroke through the blood! It was she! White, all white, from her dress to her pale face. The moment she saw him she fell into his arms, with her mouth against his mouth.

How many hours passed by in that rough, smoky little room! How many things they said to one another! The changeless insentient woodworm continued gnawing the beams of the roof. The clock in the neighbouring village let fall the hours one by one. Through a hold in the wall they could see the reflection of the shaken leaves outside, shadow alternating with green light as at the bottom of a lake.

Such is life. All at once she was as if bewildered, she passed her hand over her lips, then opened the door to see the setting sun. Then resolutely she threw her arms round his neck, saying, "I won't leave you any more."

Arm in arm they walked together to the little station not far off, lost in the deserted plain. Not to part any more! What boundless and trembling joy! To go clasped one against the other, silent, as if dazed, through the still country, in the mingled hour of evening.

Insects were buzzing about the ridge of the foot-path. From the crumbled earth a heavy, confused mist arose. Not a human voice, not a dog that barked. Far away a lonely light twinkled in the shadows. At last the train came, plumed and puffing. They set off together; to go far away, far away, into those mysterious mountains of which he had spoken to her, so that she seemed to know them already.

For ever!

For ever. They rose at daybreak, rambled round the fields, in the first dews, they sat at midday in the thick of the plants, or in the shadow of the poplars whose white leaves trembled without a wind, happy at feeling themselves alone, in the great stillness. They lingered on till late evening, to see the day die on the tips of the mountains, when the window-panes suddenly took fire and revealed the far off cabins. Darkness rose along the little roads of the valley, which now took on a melancholy air; then a gold coloured beam rested for an instant on a bush that grew on top of the low wall. This bush also had its hour, and its ray of sun. Tiny insects hummed around, in the tepid light. When winter came the bush would disappear, and sun and night would alternate once more upon gloomy bare stones, wet with rain. So had disappeared the hut of the lime-burner, and the inn of "Killwife" on the top of the little deserted hill. Only the crumbling ruins showed themselves black in the crimson of sunset. The lake spread always the same in the background of the plain, like a tarnished mirror. Nearer at hand the vast fields of Mazzaro, the thick grey olive-groves on which the sunset came down more darkly, the endless pasturage which disappeared into the glory of the west, on the crowns of the hills; and other people appeared in the doorways of the farms as big as villages, to see other travellers pass by. Nobody knew anything more about Cirino, or about Neighbour Carmine, or the rest. The phantoms had passed away. Only the solemn and changeless landscape remained, with its large eastward spaces and its hot, robust tones. Mysterious sphinx, representing the passing phantoms with a character of fatal necessity. In the village the children of the victims had made peace with the blind, bloody instruments of Liberty; shepherd Arcangelo dragged out a late old age at the expense of the young master; one of Neighbour Santo's daughters had gone as bride into the home of Master Cola. At the inn by the Lake of Lentini a hairless, half-blind old dog that had been forgotten at the door by the various inn-keepers as they succeeded one another, still barked gloomily at the rare travellers passing by.

Then the bush also went colourless, and the owl began to hoot in the distant wood.

Farewell, sunsets of the distant land. Farewell, solitary poplars, in whose shade she had so often listened to the stories he told, which have seen so many people pass, and the sun rise and set so often away down there. Farewell! She too is far away.

One day ill news came from the city. One word was enough, from a distant man whom she could not hear mentioned without going pale and bending her head. In love, young, rich, the pair of them, both of them having said that they wanted to be together for ever, and yet a word from that man had been enough to part them. It wasn't need of bread, such as had made Pino the Tome fall, nor was it the sharp knife of a jealous man. It was something subtler and stronger which parted them. It was the life in which they lived and by which they had been formed. The lovers became dumb and bowed their heads to the will of the husband. Now she seemed as if she feared the other one, and wanted to flee away from him. At the moment of parting from him she wept her many tears, which he greedily drank up; but she went all the same. Who knows how often they recall that time, in the midst of their divers excitements, at their feverish balls and parties, in the swirling succession of events, in the harsh necessities of life? How many times has she called to mind that far-off little village, that desert in which they were alone with their love, that old stump in whose shade she had lain with her head on his shoulder, saying to him with a smile, "Shade for the Camelias."

There were plenty of Camelias, and superb ones, in the splendid conservatory where the merry sounds of the feast arrived faintly, long afterwards, when another had plucked her a crimson blossom red as blood, and had put it in her hair. Farewell, far-off sunsets of the far-off countryside! And he too, when he raised his tired head to gaze into the aureole of his lonely lamp, at the phantoms of the past, what numerous images he saw, what memories came back! One place or another in the world, in the solitude of the fields, in the whirlpool of the great cities. How many things had come

to pass! And how much they had lived through, those two hearts now separated far apart!

At last they met again in the wild excitement of carnival. He had gone to the festival to see her, with his soul weary and his heart wrung with anguish. She was there, dazzling, surrounded by a thousand flatteries. But she had a tired face too, and a sad, absent smile. Their eyes met and flashed. Nothing more. Late in the evening they found themselves as if by chance near to one another, in the shade of the big, motionless palms. "Tomorrow!" she said to him. "Tomorrow, at such and such a time, in such and such a place. Let happen what may! I want to see you!" Her white delicate bosom was in storm beneath the transparent lace, and her fan trembled in her hands. Then she bent her head, with her eyes fixed and abstracted, while light and fleeting blushes passed over the nape of her neck that was of the colour of a magnolia. How hard his heart was beating! How exquisite and fearful the joy of that moment! But when they saw each other the next day, it wasn't the same any more. Why not, who can tell? They had tasted the poisonous fruit of worldly knowledge; the refined pleasure of the look and the word exchanged in secret in the midst of two hundred people, of a promise which is worth more than the reality, because it is murmured behind a fan and amid the scent of flowers, to the glitter of gems and the excitation of music. So that when they threw themselves into one another's arms, when they said with their mouths that they loved one another, they were both of them thinking with regretful, keen desire about the rapid moment the previous evening, when they had said to each other in a low voice, without looking at one another, almost without words, that both their hearts where in a whirl in their breasts at being near to one another again. When they parted once more, and were holding hands on the threshold, they were both gloomy, and not simply because they had to say goodbye — but as if something were missing from them. Still they held each other by the hand, and to each of them came the impulse to ask, "Do you remember?" But they dared not ask it. She had said she was leaving the next day by the first train, and he let

her go.

He saw her go away down the deserted avenue, and he stood there, with his forehead against the laths of the venetian blind. Evening fell, a hand-organ played in the distance at the door of a public house.

She left the next day by the first train. She had said to him, "I must go with *him!*" He too had received a telegram which called him far away. On that leaf she had written: *For ever,* and a date. But life took them both again, one this way and one that, inexorably. The following evening he also was at the station, sad and alone. People were embracing and saying goodbye; husbands and wives were parting smiling; a mother, a poor old woman of the peasantry trailed weeping after her boy, a stout young fellow in bersagliere's uniform, with his sack on his shoulder, who went from door to door looking for the way out.

The train started. First the city passed by, the streets swarming with lights, the suburb lively with merry companions. Then it began to pass like lightning through the lonely country, the open fields, the streams that glittered in the shade. From time to time a hamlet smoking, people gathered in front of a doorway. On the low wall of a little station where the train had stopped for a moment puffing, two lovers had left their obscure names written in big charcoal letters. He was thinking that she too had passed that way in the morning, and had seen those names.

Far, far away, long after, in the immense misty and gloomy city, he still recalled at times those two humble unknown names, amidst all the crowded, hurrying throng, and the incessant noise, and the fever of immense general activity, exhausting and inexorable; among the luxurious carriages, and men who must walk through the mud bearing two boards covered with advertisements, and in front of the splendid shop-windows glittering with gems, or beside squalid slum-shops which displayed human skulls and old boots spread out in rows. From time to time he heard the whistling of a train passing under earth or through the air overhead, rushing to disappear in the distance, towards the pale horizon, as if it longed for the country of the sun. Then

again came into his mind the names of those two unknown folk who had written the story of their humble joys on the wall of a house in front of which so many people must pass. Two blond, calm young creatures were walking slowly through the wide avenues of the garden, hand in hand; the youth had given the girl a little bunch of crimson roses for which he had bargained anxiously for a quarter of an hour with a ragged, miserable old woman; the girl, with her roses in her bosom like a queen, was disappearing along with him far from the crowd of amazons and superb carriages. When they were alone under the big trees of the water-side, they sat down side by side, talking together in low tones, in the calm expansion of their affection.

The sun sank in the vivid west, and even there, down the deserted avenues, came the sound of the hand-organ with which a beggar from far-away villages was going round begging his bread in an unknown tongue.

Farewell, sweet melacholy of sunset, silent shadows and wide, lonely horizons of our known country. Farewell, scented lanes where it was so lovely to walk together arm in arm. Farewell, poor, ignored people who opened your eyes so wide, seeing the two happy ones pass by.

Sometimes, when the sweet sadness of those memories came over him, he thought again of the humble actors in the humble dramas, with a vague, unconscious inspiration of peace and of forgetting, and of that date and of those two words — *for ever* — which she had left with him in a moment of anguish, a moment that had remained more living in heart and mind than any of the feverish joys. And then he would have liked to set her name on a page or on a stone, like those two unknown lovers who had written the record of their love on the wall of a far-away railway station.

THE END

THE SHORT SICILIAN NOVELS

GIOVANNI VERGA, the Sicilian novelist and playwright, is surely the greatest writer of Italian fiction, after Manzoni.

Verga was born in Catania, Sicily, in 1840, and died in the same city, at the age of eighty-two, in January, 1922. As a young man he left Sicily to work at literature and mingle with society in Florence and Milan, and these two cities, especially the latter, claim a large share of his mature years. He came back, however, to his beloved Sicily, to Catania, the seaport under Etna, to be once more Sicilian of the Sicilians and spend his long declining years in his own place.

The first period of his literary activity was taken up with "Society" and elegant love. In this phase he wrote the novels *Eros, Eva, Tigre Reale, Il Marito di Elena,* real Italian novels of love, intrigue and "elegance": a little tiresome, but with their own depth. His fame, however, rests on his Sicilian works, the two novels: *I Malavoglia* and *Mastro-Don Gesualdo*, and the various volumes of short sketches, *Vita dei Campi (Cavalleria Rusticana), Novelle Rusticane,* and *Vagabondaggio*, and then the earlier work *Storia di Una Capinera*, a slight volume of letters between two school-girls, somewhat sentimental and once very popular.

The libretto of *Cavalleria Rusticana*, the well known opera, was drawn from the first of the sketches in the volume *Vita dei Campi*.

As a man, Verga never courted popularity, any more than his work courts popularity. He kept apart from all publicity, proud in his privacy: so unlike D'Annunzio. Apparently he was never married.

In appearance, he was of medium height, strong and straight, with thick white hair, and proud dark eyes, and a big reddish moustache: a striking man to look at. The story *Across the Sea*, playing as it does between the elegant life of Naples and Messina, and the wild places of south-east Sicily, is no doubt autobiographic. The great misty city would then be Milan.

Most of these sketches are said to be drawn from actual life, from the village where Verga lived and from which his family originally came. The landscape will be more or less familiar to any one who has gone in the train down the east coast of Sicily to Syracuse, past Etna and the Plains of Catania and the Biviere, the lake of Lentini, on to the hills again. And anyone who has once known this land can never be quite free from the nostalgia for it, nor can he fail to fall under the spell of Verga's wonderful creation of it, at some point or other.

The stories belong to the period of Verga's youth. The King with the little Queen was King Francis of Naples, son of Bomba. Francis and his little northern Queen fled before Garibaldi in 1860, so the story *So Much For the King* must be dated a few years earlier. And the autobiographical sketch *Across the Sea* must belong to Verga's first manhood, somewhere about 1870. Verga was twenty years old when Garibaldi was in Sicily and the little drama of *Liberty* took place in the Village on Etna.

During the 'fifties and 'sixties, Sicily is said to have been the poorest place in Europe: absolutely penniless. A Sicilian peasant might live through his whole life without ever possessing as much as a dollar, in hard cash. But after 1870 the great drift of Sicilian emigration set in, towards America. Sicilian young men came back from exile rich, according to standards in Sicily. The peasants began to buy their own land, instead of working on the half-profits system. They had a reserve fund for bad years. And the island in the Mediterranean began to prosper as it prospers still, depending on American resources. Only the gentry decline. The peasantry emigrate almost to a man, and come back as gentry themselves, American gentry.

Novelle Rusticane was first published in Turin, in 1883.

D. H. LAWRENCE

Italian literature from Dedalus:

Senso (and other stories) - Camillo Boito £6.99
The Child of Pleasure - Gabriele D'Annunzio £7.99
The Triumph of Death - Gabriele D'Annunzio £7.99
L'Innocente (the Victim) - Gabriele D'Annunzio £7.99
La Madre (The Woman and the Priest)
 - Grazia Deledda £5.99
The Late Mattia Pascal - Luigi Pirandello £6.99
The Notebooks of Serafino Gubbio
 - Luigi Pirandello £7.99
Cavalleria Rusticana - Giovanni Verga £5.99
Mastro Don Gesualdo - Giovanni Verga £6.99
I Malavoglia - (The House by the Medlar Tree)
 - Giovanni Verga £7.99
Short Sicilian Novels (Novelle Rusticane)
 - Giovanni Verga £6.99
Sparrow (La Storia di una Capinera)
 - Giovanni Verga £6.99
The Garden of Eden - Alberto Savinio (included in **The Dedalus Book of Surrealism** - editor Michael Richardson) £8.99

All these books can be obtained from your local bookshop, or by writing to: **Dedalus Cash Sales, Langford Lodge, St. Judith's Lane, Sawtry, Cambs, PE17 5XE.**
Please enclose a cheque to the value of the books ordered, plus £1 postage & packing for the first book and 75p thereafter up to a maximum of £4.75

**I Malavoglia (The House by the Medlar Tree)
by Giovanni Verga**

"*I Malavoglia* obsessed me from the moment I read it. And
when the chance came I made a film of it La Terra Trema."
Luchino Visconti

I Malavoglia is one of the great landmarks of Italian
Literature. It is so rich in character, emotion and texture that
it lives forever in the imagination of all who read it. What
Verga called in his preface a 'sincere and dispassionate study
of society' is an epic struggle against poverty and the elements
by the fishermen of Aci Trezza, told in an expressive language
based on their own dialect.

"Giovanni Verga's novel of 1881, *I Malavoglia*, presented its
translator, Judith Landry, with formidable problems of dialect
and peasant speech which she has solved so unobtrusively
that one wonders why this moving and tragic tale is so little
known in Engaland."
Margaret Drabble in The Observer

"This is a tragic tale of poverty, honour and survival in a
society where the weak go to the wall unmourned"
The Sunday Times

£7.99 ISBN 0 946626 88 X 288p B.Format